IMAGES
of America

KEARNEY'S
HISTORIC HOMES

IMAGES
of America

KEARNEY'S
HISTORIC HOMES

Brian Whetstone, Jessie Harris,
and the Buffalo County Historical Society

ARCADIA
PUBLISHING

Published by Arcadia Publishing
Charleston, South Carolina

Printed in the United States of America

Library of Congress Control Number: 2013935520

For all general information, please contact Arcadia Publishing:
Telephone 843-853-2070
Fax 843-853-0044
E-mail sales@arcadiapublishing.com
For customer service and orders:
Toll-Free 1-888-313-2665

Visit us on the Internet at www.arcadiapublishing.com

*We would like to dedicate this book to our families and friends for
all of their love and support. We could not be more thankful!*

CONTENTS

ACKNOWLEDGMENTS

This book would not have been possible without the extraordinary help from the outstanding people in the Kearney community. First of all, we would like to thank our friends and family for their ongoing love and support throughout not only this project, but in our lives as well. We would also like to acknowledge the staff at the University of Nebraska at Kearney's Frank House for helping us discover our common love of history—in particular KrisAnn Sullivan, for supporting us and for helping to get this project started.

Much of the research was made possible thanks to Pat Jones, the many resources available at the Buffalo County Historical Society Trails and Rails Museum, and Main Street Kearney, by letting us do extensive research and borrow books and images for research purposes. Greg Anderson and Mark Ellis at the University of Nebraska at Kearney have also been a great help with the book. Jennifer Murrish at Trails and Rails was also key in the early development of this project. We also thank the Buffalo County Historical Society board for its coauthoring with us and letting us have exclusive access to the society's seemingly limitless resources. Finally, we would like to thank Jon Bokenkamp for providing extensions in establishing communication with helpful people in the community.

Unless otherwise noted, images are provided courtesy of the Buffalo County Historical Society.

INTRODUCTION

In 1871, Rev. D.N. Smith, who was serving as an agent for the townsite department of the Burlington Railway Company, selected the site for a town to be located at the junction of the Burlington and the Union Pacific Railroad. He was assisted by Moses Sydenham, who would later try to move the capital of the United States to Kearney, and Rev. Asbury Collins. Nearly a year before the junction was completed, the South Platte Land Company, through Reverend Smith, acquired 1,473 acres of land covering the junction point of the two railroads. This was done at a cost of just over $3 per acre. This site would one day become the city of Kearney.

From its early beginnings, Kearney, first known as Kearney Junction, did not have much to boast. Wyoming Avenue (Central Avenue) and a few side streets were mainly what the town was composed of. Homes were rare and were often simple, American Foursquare–style houses, many of which have not survived the test of time and are no longer in existence. In the town's early years, many hardships were suffered by the townspeople in their attempts to undergo building activity. The Easter blizzard of April 13, 1873, and the grasshopper scourges of 1875 and 1876 were natural events that hampered the expansion and progress of the small townsite.

By the fall of 1872, there were enough people living in the new settlement to encourage the organization of the village of Kearney Junction. By December 3, 1873, the City of Kearney was established. Kearney continued to grow rather slowly until 1885, when George Washington Frank and his family arrived. His son, George William Frank, an architect, designed many of the important structures that would dominate the skyline of Kearney. After the family's arrival and the elder Frank's establishment of an electric company and construction of a power plant, the city was rushed into an unprecedented era of boom and industrialism. This era of growth and urban development was enough to earn the town the nickname "Minneapolis of the West." The city was also considered a good stopping point along the railroad—and, later, the Lincoln Highway—due to the often advertised "fact" that Kearney is located exactly 1,733 miles from both Boston and San Francisco. In naming the town, the name Midway City was almost considered.

The influence of this boom period is reflected through the history of many of the homes. In 1890, Kearney had 1,520 houses, 736 of which had been built since 1888. Many of these were not just simple homes but mansions. The architectural designs were Victorian and the interiors were ornately decorated and sumptuously furnished. Many had ballrooms, studies, butlers' kitchens, open stairways with carved balustrades, and fireplaces in many rooms.

This extensive home-building during the boom period was brought to a screeching halt by the depression of 1893. Many of the Eastern investors who had built their large, ornate homes quickly sold them to move to an area of the country that was not suffering so hard. These homes were usually built on two to three lots, which were then often split up and sold individually. Kearney suffered more drastically than other parts of the country due to the establishment of a cotton mill in the early 1890s that did not generate a profit and therefore limited the town's financial resources. Kearney does not have as many houses from the early 1900s. It was not until the

establishment of the Kearney State Normal School in 1905, and then again after World War II, that the city went through any more major housing booms.

East Lawn, Pioneer Park, Kenwood, and West Kearney were some of the most notable neighborhoods upon their establishment in the late 1880s. East Lawn and West Kearney no longer exist, and the large mansions located within their plots of land were either torn down or moved farther into town. Many of the other homes still in existence are fine examples of their specific periods of architecture, while others have been extensively remodeled into apartment homes, club homes, or nursing homes.

This book will try to explain the elaborate and colorful history behind not just Kearney's homes, but also the neighborhoods the homes are located in, through unique vintage photographs and captions explaining the rich history behind these images. Many of these photographs were compiled from the photographic collections of Alfred T. Anderson, who captured many of the sights and scenes of Kearney in the 1800s. Many photographs were also taken from the extensive archives at both the Buffalo County Historical Society and the University of Nebraska at Kearney's historic Frank House. John Stryker, an early college professor at Kearney State Normal School, was also a photographer who captured many images of Kearney in the early 1900s. In addition to Anderson's, many photographs from Stryker's collection are seen in this book. Due to copyright issues, photographs from the Solomon Butcher collection do not appear in this publication.

Today, Kearney is a vibrant and active community slowly taking the steps toward the preservation of both homes and public buildings. Since its 1880s boom, the town has expanded rapidly both north, east, south, and west, shooting past the neighborhoods that once dominated the social aspects of Kearney's everyday life but still managing to maintain a delicate balance of both old and new, with many neighborhoods coming back into mainstream popularity. The authors encourage people who are in possession of historical or vintage photographs to share them with their communities by donating them to their local historical societies or museums, so they may continue to inspire a love of history throughout future generations.

One

ORIGINAL KEARNEY

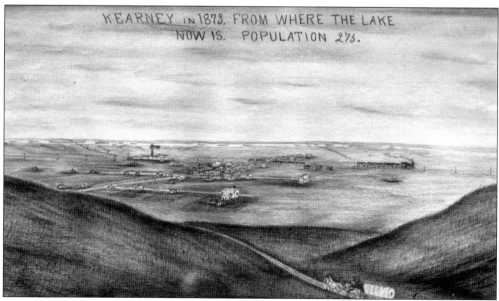

In 1871, Rev. D.N. Smith, who was serving as an agent for the townsite department of the Burlington Railway Company, selected the site for a town to be located at the junction of the Union Pacific and the Burlington Railroads. He was assisted by Moses Sydenham and Rev. Asbury Collins. This junction became the future site of Kearney. Reverend Collins and Louisa Collins were Kearney's first settlers. (Courtesy of the University of Nebraska at Kearney, Frank House.)

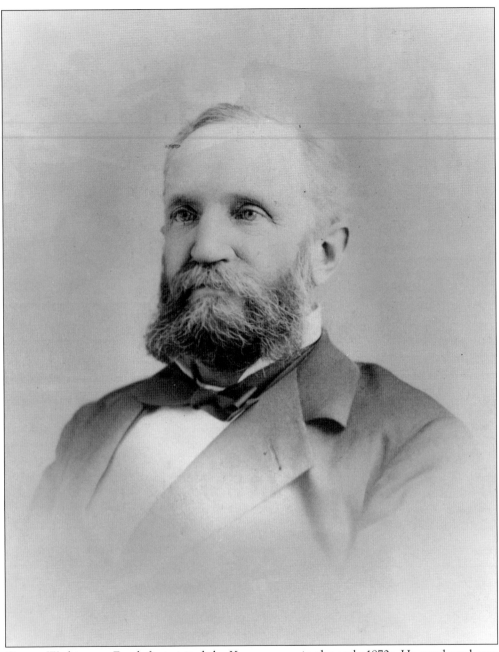

George Washington Frank first visited the Kearney area in the early 1870s. He purchased over 1,000 acres of land and, upon his return to Kearney in 1885, helped establish the Kearney Electric Company and helped bring about the immense boom period beginning in the late 1880s. In 1890, Frank had also started an electric streetcar system two years before San Francisco's went into service.

Moses Sydenham planned to move the nation's capital to Kearney. He used the central location and the good transportation systems as support for his proposal. He also offered to serve as an agent to sell the Fort Kearny Military Reservation to private purchasers and use the funds to pay for the construction of government buildings. The capital itself would sit on the high ground west of Second Avenue. Amazingly enough, the scheme was given enough attention to be taken to court in Washington, DC, where the decision was reached for the capital to remain there.

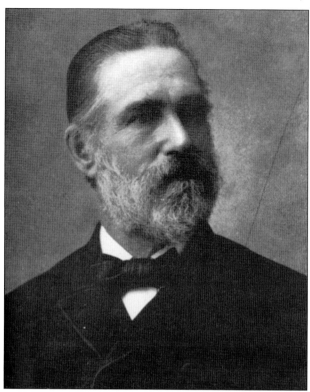

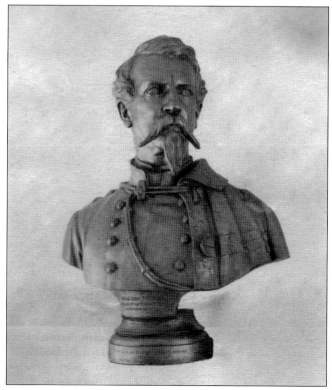

From 1871 to 1873, this small townsite was known as Kearney Junction. In 1873, the town's name was changed to Kearney, named for Gen. Stephen Watts Kearny, the famed Mexican-American War general. The spelling of Kearney's name was due to a postal mix-up, with the postman spelling General Kearny's last name wrong by adding an extra *e*. This is a photograph of a bust of General Kearny. (Courtesy of the University of Nebraska at Kearney, Frank House.)

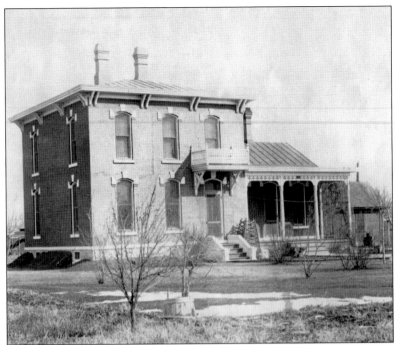

This house, one of the earliest in the town, belonged to Nathan Campbell, one of the early mayors of Kearney, in 1874. Originally located near Good Samaritan Hospital, the house was later used as nurses' quarters before being demolished for further construction of the hospital.

Nathan Campbell had many ideas for the new town. One such idea was that the streets should run farther northward. Campbell argued that this would be beneficial for the town's future development. The city founders did not agree with Campbell's idea, however, and turned the proposal down. In retaliation, Campbell hired a surveyor to find the exact middle point of Central Avenue, which he then proceeded to build his house upon. Interestingly, Campbell was proven correct about 100 years later, when the city began rapidly expanding northward. Good Samaritan Hospital took the place of the home in the exact same position, right in the middle of Central Avenue. Good Samaritan Hospital is seen here shortly after it was first built.

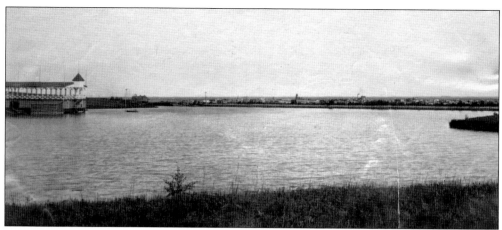

Another early-1870s home belonged to Nahum Gould, the first Presbyterian minister in Kearney, who arrived in 1872. His residence, built on the hillside near Kearney Lake, was a three-story house in front, with each of the three floors opening onto the ground level, at the back and along one of the sides. Seen here is Kearney Lake, with a pavilion that was built later, in the 1880s. (Courtesy of the University of Nebraska at Kearney, Frank House.)

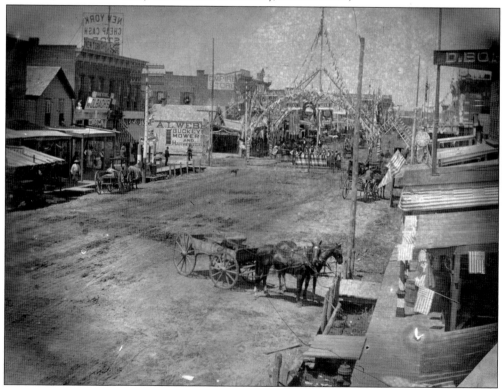

Even with the housing boom following the grand days of the 1880s in Kearney, many people still chose to build their homes in the original Kearney area. This area was composed of Central Avenue, Avenues A, B, and C, and First and Second Avenues. Many of these homes belonged to some of the wealthier businessmen who owned business blocks on Central Avenue. This photograph shows Wyoming Avenue as it looked in the 1870s–1880s. (Courtesy of the University of Nebraska at Kearney, Frank House.)

Recognizable structures in this view of the skyline are the Midway Hotel (center left), the flour mill along the railroad (horizon line right), and Whittier High School (center right). (Courtesy of the University of Nebraska at Kearney, Frank House.)

As industry began to take hold of Kearney in the late 1880s, many of the original wooden business buildings were replaced with impressive brick business blocks built by many of Kearney's most prominent investors. The Cunningham's Journal Building is seen at right. Below is the business building constructed by John Barnd and Sylvestor St. John, the present-day location of Shopping Tripps. (Both, courtesy of the University of Nebraska at Kearney, Frank House.)

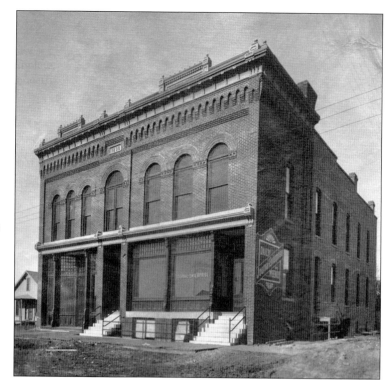

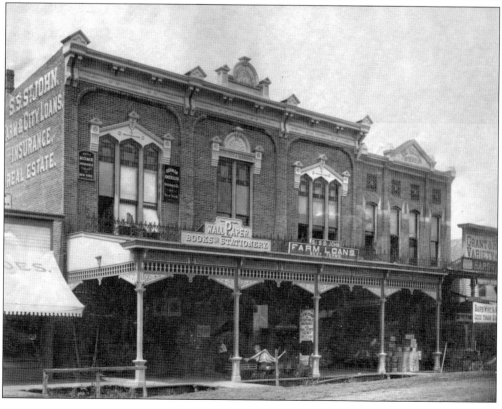

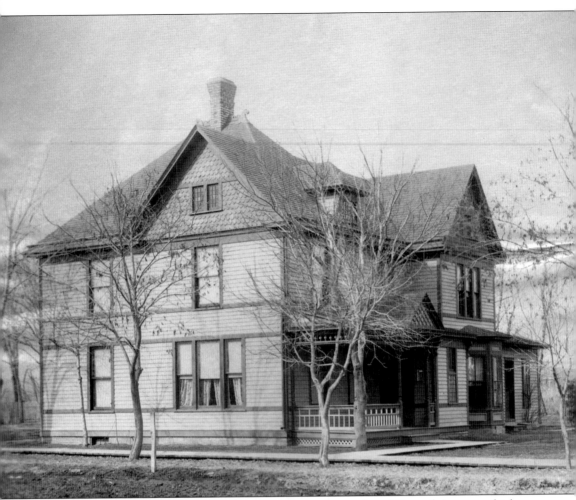

Sylvester St. John chose to build his home on the northern edge of Central Avenue, which was one of the farthest edges of town at the time. He had published a newspaper in Wisconsin and was a printer by trade. When he moved to Kearney, St. John decided to invest in an agricultural implement business on the west corner of Wyoming (Central) and Eleventh Avenues. (Courtesy of the University of Nebraska at Kearney, Frank House.)

Located on Avenue B, another landmark home was the early home of the Roy Bodinson (pictured), a local hardware store owner. His store was located at 2116 Central Avenue. Today, the house exists as the White House Apartments. The structure has had a few additions but otherwise has been well maintained.

This Queen Anne home, located near the Bodinson residence, was most likely built in the early 1880s. It still retains many of its original architectural features.

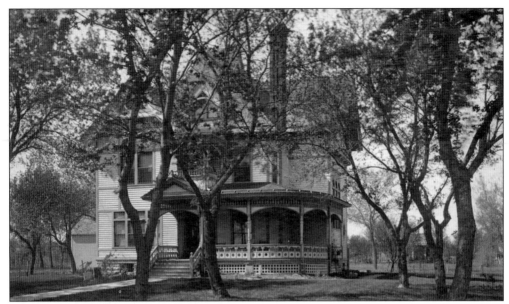

As the story goes, this home was built by a man who had saved the life of Charles Francis Adams in the Civil War. Adams gave the other man money to build the home as a repayment for his rescue, and the Kearney man was later forced to sell the house. It was purchased by John Barnd, a famed local judge and attorney, in the 1880s. The land surrounding the home was privately owned by Barnd. In the housing boom of the 1960s, the land was sold off and built on. This home is now listed in the National Register of Historic Places. (Courtesy of the University of Nebraska at Kearney, Frank House.)

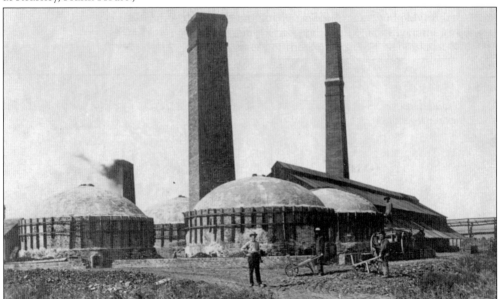

The area that was the northernmost edge of Kearney in the early years of its development was home to many brickmaking factories. The most prominent among them was the Hibberd Brick Company. Located where Kearney Catholic High School is today, it was rumored to be the best spot, where the clay in the soil was just right for bricks. Around this area, workers built their own small homes, many of which still survive today, although some have been moved off their original properties.

18

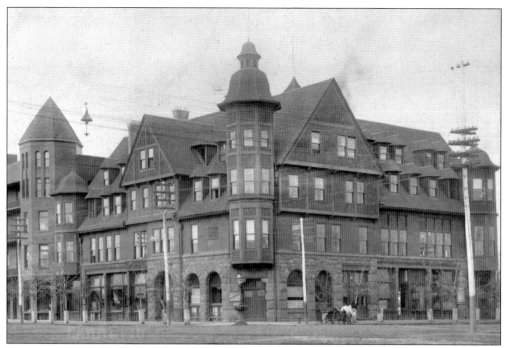

Construction on the Midway Hotel began in 1886, and it officially opened in 1888. It had more than 80 rooms, each complete with gas fixtures and bathrooms. On March 24, 1890, the hotel caught fire due to sparks from a chimney. The entire structure was destroyed before firemen could get to the scene. Mayor Charles Finch ordered the construction of a new hotel on the same site, and a total of $6,000 was granted "as the ashes were smoldering," the *Kearney Daily Hub* reported.

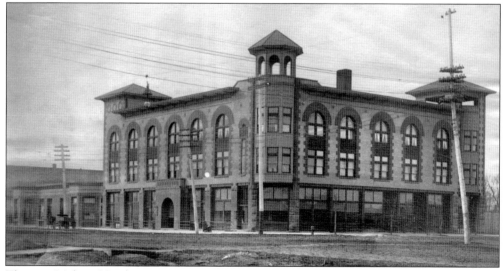

The new Midway Hotel was in operation from 1890 until 1967. The hotel was also the home of J.L. Keck and his family, who owned and operated it for many years. The new Midway was as extravagant as the one that preceded it and included a special room on the east side of the building named the Rose Room. The room featured stained-glass windows, and many people would gather there in the mornings and watch the sunrise. The Midway was replaced by a Safeway, and the site is now the location of an Apple Market.

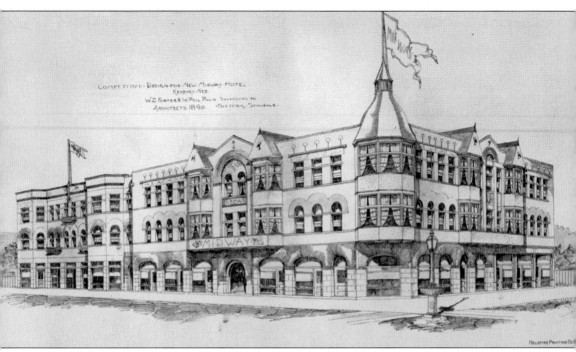

One of the most prominent residential and public architects in Kearney was George William Frank. The son of influential businessman George Washington Frank, the younger Frank did not even graduate from architecture college. Yet, he went on to design buildings such as Green Terrace Hall, the city hall, and many residential homes. Seen here is his competitive, and nonwinning, design for the Midway Hotel. (Courtesy of the University of Nebraska at Kearney, Frank House.)

Construction on city hall began in 1889 and was completed in 1890, with Charles B. Finch the first mayor to inhabit the new building. City hall featured an interesting clock tower, and the building also housed the city's fire department. In 1939, the structure was dismantled as part of a WPA project to help those in need of a job during the Great Depression. In that same year, the new city hall was constructed in the same location. It is still there today. (Courtesy of the University of Nebraska at Kearney, Frank House.)

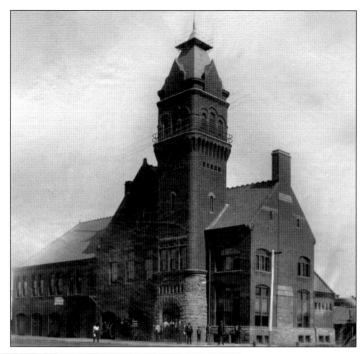

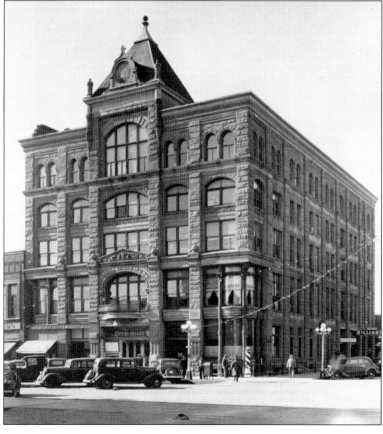

Perhaps one of Kearney's most imposing and prominent buildings was the Kearney Opera House. Construction on it began on May 1, 1890, and it had its grand opening on May 1, 1891. The building was five stories high with a basement and cost a total of $140,000. The walls of the structure were 22 inches thick.

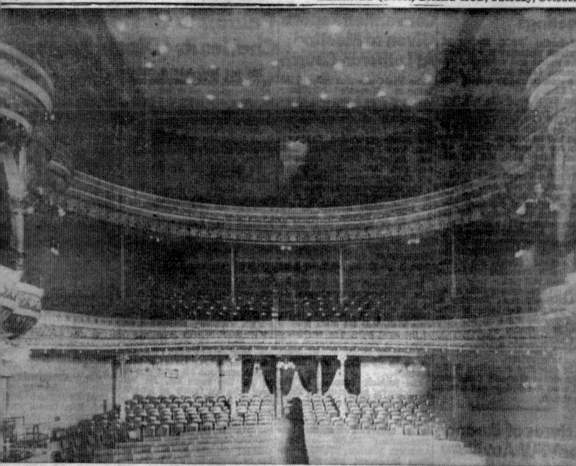

\ST GLORY. Kearney's opera house, once described as "the st imposing structure in Nebraska outside Lincoln and aha," soon will be only a fond memory in the minds of old-ers around Central Nebraska. The interior of the opera se theater is shown here in its full glory as it looked in the resplendent with gilt boxes, plush seats and simulated out-dor "star" lighting by electricity. For almost two decades a its opening in 1891, the theater attracted top-hatted audie from Grand Island, Lexington, Ravenna and other nearby ci to the Broadway production which stopped off here on t road trip between Omaha and Denver. The building is sched to go under demolition crew's hammers starting Nov. 1.

The second-floor exterior balcony of the Kearney Opera House was large enough to hold an 18-piece band. The theater had a red carpet that went down the center, and the space was complete with two balconies and ten ornately gilded box seats. There was also 96 lights placed in different places on the ceiling, with candles powering them to act as stars for the sky, but the electric lights of the building were also backed with gas. Many world-famous people appeared at the opera house, including Harry Houdini, John Philip Sousa, Lionel Barrymore, and William Jennings Bryan. (Courtesy of the University of Nebraska at Kearney, Frank House.)

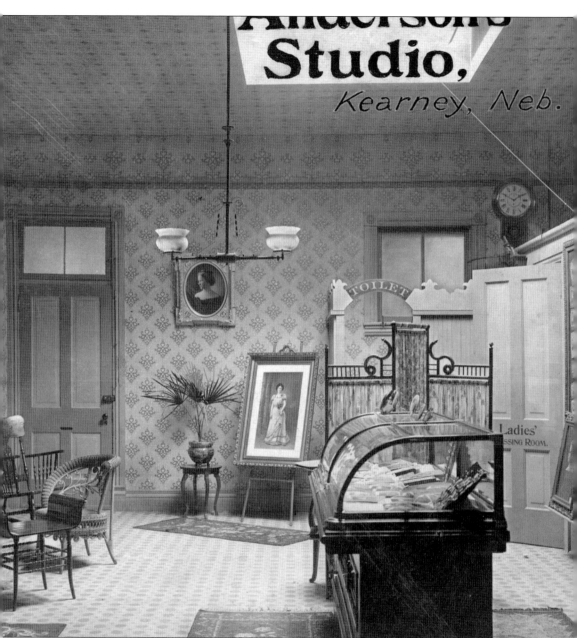

Alfred T. Anderson was a famous photographer in Kearney. A Swedish immigrant, he began his career when he was 16. Augustus Frank, George Washington Frank's eldest son, gave Anderson a good start by hiring him to take 50 eight-inch-by-ten-inch photographs of Kearney and ordering six prints of each. These pictures were seen by many people and helped Anderson's career take off. Anderson's studio was originally at 2111 Central Avenue and later moved to 14 West Twenty-second Street, the present-day site of Nelson's Furniture Store. Many of his photographs are still used in publications, web articles, and museums throughout Kearney today.

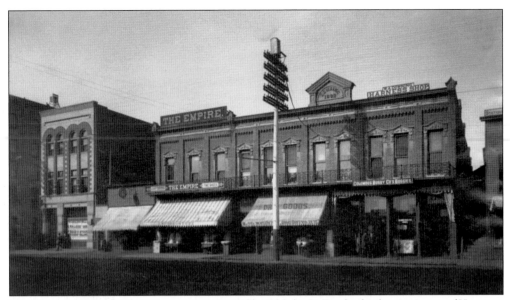

The Empire was a local department store owned by Charles B. Finch, the former mayor of Kearney. It offered a variety of clothing for men, women, and children. The store was originally next door to the building that is now the site of Tru Café. (Courtesy of the University of Nebraska at Kearney, Frank House.)

R.A. Moore built this truly interesting home in the late 1880s. He had come to Kearney in the early 1880s and was an attorney. (Courtesy of the University of Nebraska at Kearney, Frank House.)

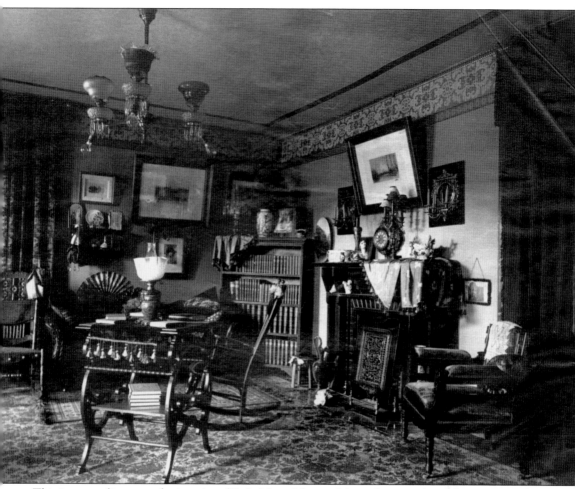

This is a rare glimpse at the interior of R.A. Moore's home. Many photographs of the exteriors of local homes were taken in the 1880s and 1890s, but hardly any were any taken of the interiors. Many of these homes were furnished with materials such as tiles, woodwork, and furniture imported from other parts of the United States or Europe. Many Victorians enjoyed trinkets and stylings from the Far East. Note the light fixture in this room. Originally gas, the light was converted to electric most likely after 1886, when electricity became more prominent in Kearney. (Courtesy of the University of Nebraska at Kearney, Frank House.)

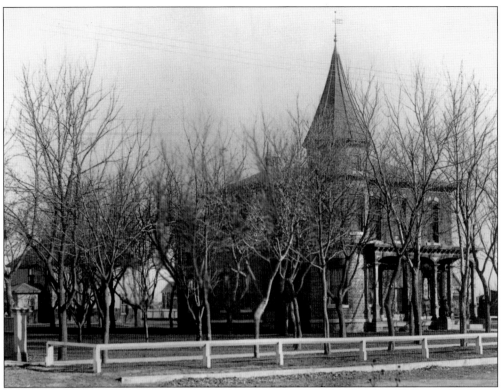

F.G. Keens built his impressive towered brick home in the early 1880s. Keens was involved with many construction projects in Kearney and also built the Mount Carmel Home. Later, Keens's home caught on fire, which destroyed the upper stories. Rather than tearing the house down, the second and third floors were removed. The one-level house still stands today.

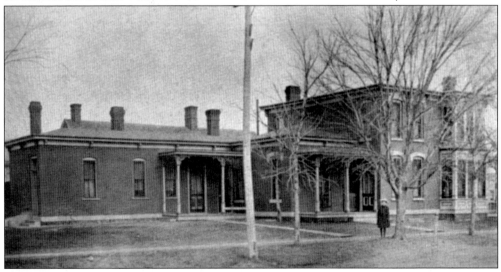

This is the early home of D. Wort, a grain company owner in Buda who eventually relocated his family to Kearney. The residence was complete with its own attached stables. The home was designed in the Italianate style, and its front porch was replaced with stone columns in the Prairie style. Today, it is home to the Village Hairsmith, a local barbershop.

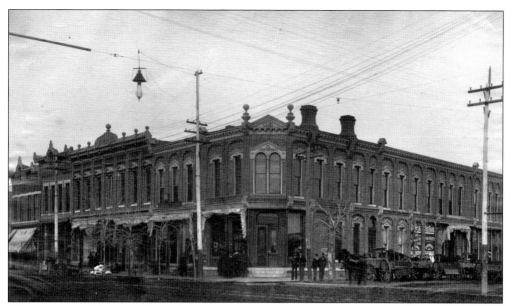

Many of the buildings on Central Avenue were not only business blocks but also included many apartments. Some of the upper stories were also used as extra office space. Seen here is the Lowe Building. Built in 1881, it is one of Kearney's oldest business buildings. Today, many of the upper stories of structures in the area are unfortunately falling into disrepair. (Courtesy of the University of Nebraska at Kearney, Frank House.)

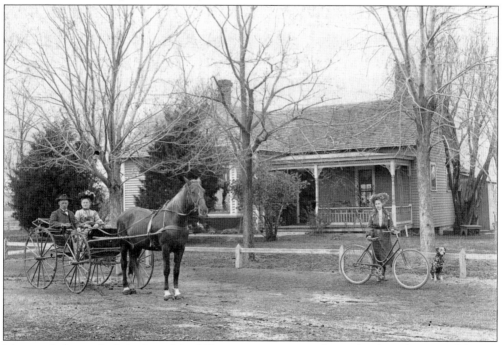

Many early homes built in the original Kearney area were much simpler than the more elaborate Queen Anne or Eastlake houses of later years. Most of these homes were designed in the American Foursquare or vernacular styles. To brighten up the simplistic designs of these homes, most owners built elaborate porches.

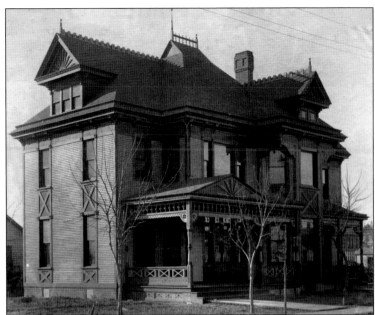

D.B. Clark built this house in 1890. The August 5, 1890, *Kearney Daily Hub* reports that the home had been broken into. The burglar was never found. In 1923, the house was purchased from Dora and Daniel Herbert and turned into the Mother Hull Home. It was on Avenue B and was eventually torn down in 1976. (Courtesy of the University of Nebraska at Kearney, Frank House.)

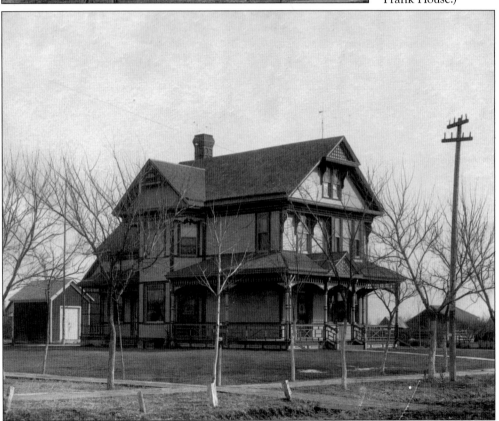

R.R. Greer built his home on Avenue A in the 1880s. Greer was president of the Nebraska State Fair Association and invested much of his time and money in real estate. This home is no longer standing.

Two

PIONEER PARK

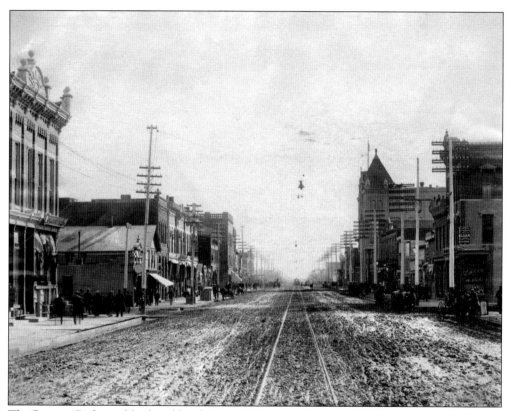

The Pioneer Park neighborhood has been around since as early as 1885, when many of Central Avenue's main business blocks began to relocate northward. The homes located in this area belonged to many of Kearney's founders and prominent businessmen. (Courtesy of the University of Nebraska at Kearney, Frank House.)

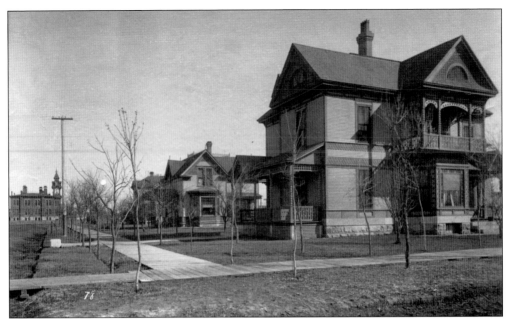

In 1893, there was a severe economic depression, closely followed by the drought of 1894. Both of these unfortunate events led to the end of Kearney's boom period and a decline in the population. Many speculators who had invested in property and real estate around Kearney began dividing blocks into lots and selling them for as little as $200. This is an early look down Third Avenue in the late 1800s. (Courtesy of the University of Nebraska at Kearney, Frank House.)

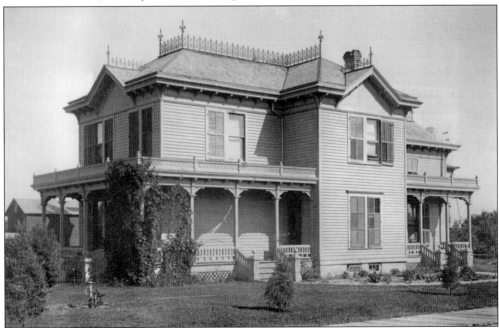

H. Gibbons built his home in the Pioneer Park neighborhood in the late 1880s. Gibbons owned a business on Central Avenue. The home was added on to many times before being torn down. An apartment house now sits in its place. (Courtesy of the University of Nebraska at Kearney, Frank House.)

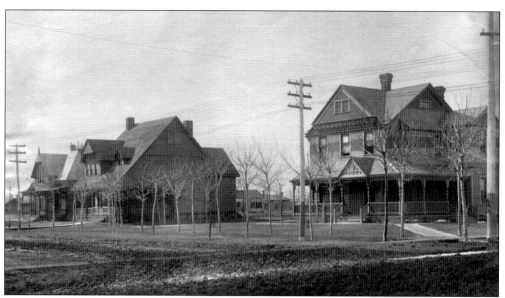

J.D. Hawthorne was in Kearney as early as 1878, when he started his jewelry business and chose to build his home in the Pioneer Park neighborhood. Today, his jewelry store is still in business and his home, seen here on the far right on Fourth Avenue, is still standing. (Courtesy of the University of Nebraska at Kearney, Frank House.)

S.M. Nevius, an early attorney, built his unusual home on West Twenty-second Street in 1884. His daughter Frances was the first schoolteacher in Kearney in 1874. It was reported that Nevius threw quite the party at his residence. Today, after several additions and changes, the house is owned by the fourth generation of the Lowe family. (Courtesy of the University of Nebraska at Kearney, Frank House.)

Walter Barney chose the site across the street from Austin J. Gallentine to build his home in 1900. Barney established an insurance company in 1888 that is still in operation today. (Courtesy of the Pioneer Neighborhood Association.)

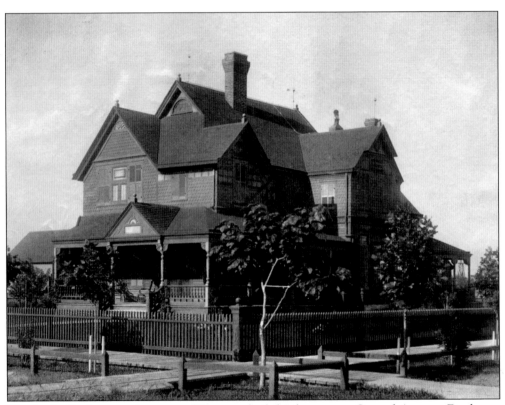

Charles B. Finch, an early mayor of Kearney, built his home near Second Avenue. Finch was in charge of several internal improvements for Kearney, including the renaming of streets, the installation of a sewer system, and the renumbering of all the homes. After several additions and exterior changes, the home's current owners have been making an effort to bring the home back to its 1880s glory. (Courtesy of the University of Nebraska at Kearney, Frank House.)

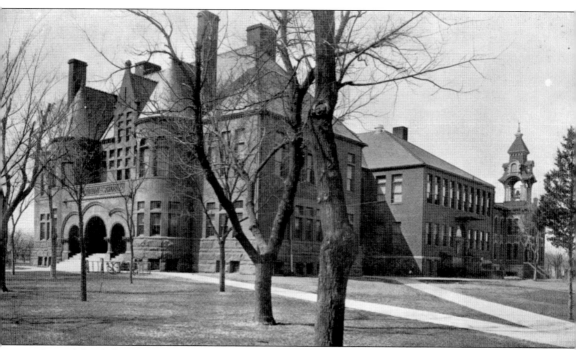

One of the defining buildings of the Pioneer Park neighborhood was Longfellow High School. Constructed in 1890 by popular local architect George William Frank, the building was made of sandstone and red pressed brick with white oak interior detailing. In 1912, the building was added on to in the back, and it underwent remodeling and updating in the 1930s. In the 1960s, it was torn down after the completion of the new high school at a site farther north.

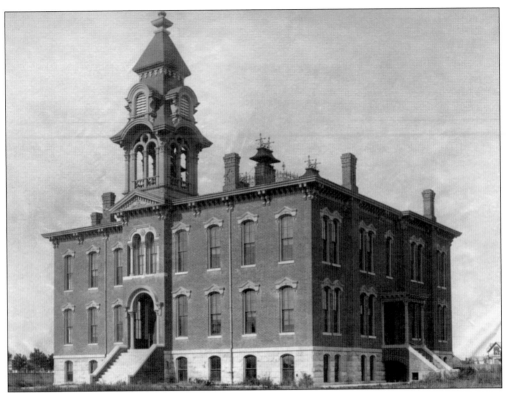

Located near Longfellow High School was the Whittier School. Constructed in 1884, it was Kearney's high school until the completion of Longfellow, when Whittier became an elementary school. In the 1920s, the whole block was completed with the building of Central Junior High School, which still stands today and is listed in the National Register of Historic Places. (Courtesy of the University of Nebraska at Kearney, Frank House.)

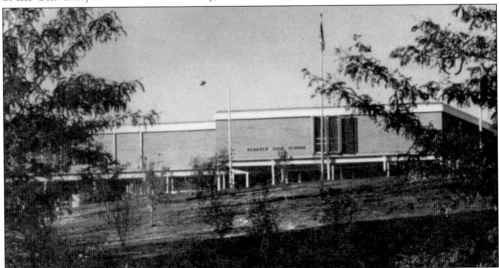

By the 1960s, Longfellow had been torn down to make way for the new Kearney High School. Shown here is the new Kearney High School building that replaced Longfellow. Where Longfellow once stood is now a parking lot for the Merryman Performing Arts Center.

Another imposing home belonged to F.Y. Robertson, a prominent banker in town. He was the president of the First National Bank. The home is made of brick, although the brick is now covered by a layer of stucco. It is one of the only homes in town that still retains its cast-iron widow's walk. (Courtesy of the University of Nebraska at Kearney, Frank House.)

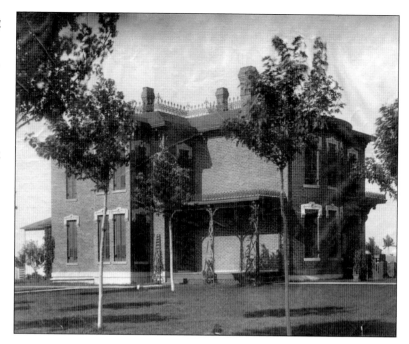

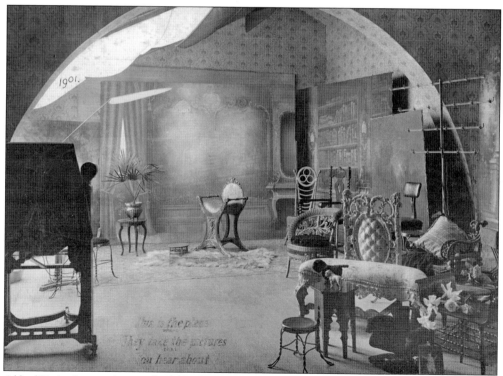

Alfred T. Anderson chose to build his home in the area. A famous photographer who came from Sweden, Anderson immigrated to the United States at the age of 16. He got his first big job from Augustus Frank when he took many photographs that featured the more prominent businesses and homes around town. Anderson's studios operated until the 1940s on Central Avenue.

Warren Pratt came to Kearney in 1881 and engaged himself in the practice of law. His firm, Calkins & Pratt, operated quite successfully for 33 years. He chose to build his home around 1885 in the Queen Anne style with a neoclassical porch. The home has remained the same architecturally for over 100 years. (Courtesy of the Pioneer Neighborhood Association.)

G. Henry Cutting relocated to Kearney in May 1874 and opened up a large farm, which he kept up until 1876. He then became the department postmaster. His home was built on West Twenty-second Street, the major artery of the Pioneer neighborhood. Later on, it became an orphanage. After a few additions and changes, the home exists today as an apartment complex.

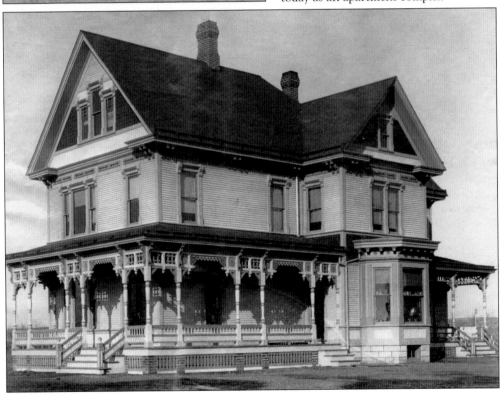

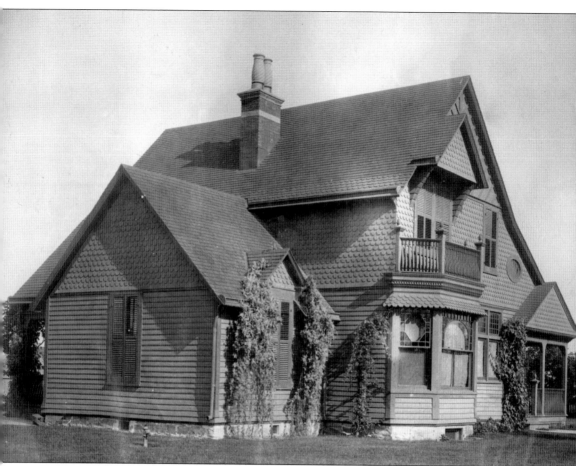

George W. Sherwood, a lumber dealer, bought half a block from the South Platte Land Company and built his interesting, eclectic house at 2310 Fourth Avenue. In February 1889, H.D. Watson, an influential rancher, bought the home for $20,000. A month later, he sold it to George Washington Frank, who sold it to another buyer in October. By January 1890, Sherwood bought it back for $13,000. He eventually sold it to George P. Rowell in 1908. The house had several owners after that and often stood vacant. After World War II, the Greater Kearney Corporation was organized to encourage the building of houses to relieve a severe shortage. The corporation bought the house in 1946 and split it in two, carrying the southern wing off and moving the main section around the corner to Twenty-fourth Street.

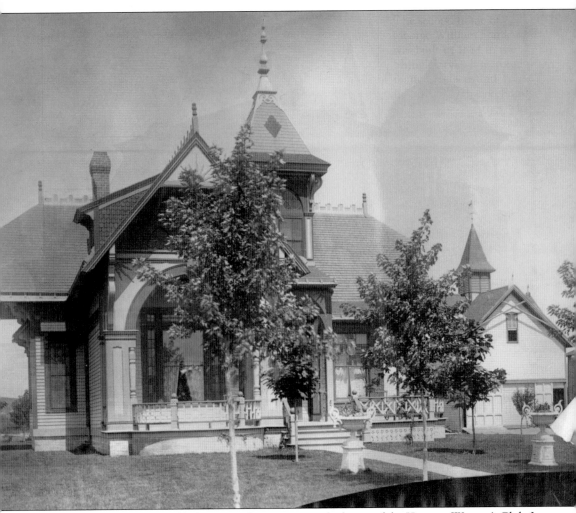

One of the most recognizable homes in the area is now the home of the Kearney Women's Club. It was built by Charles Hanson in 1886, but the Hansons only lived in the house for a year. Hanson overextended his business ventures and went bankrupt; later, his five-year-old son Arthur died in the home. Hanson left the house and returned to business ventures when he had regained his footing, eventually building two more interesting homes in Kearney. In 1887, Wallace G. Downing bought the home from Hanson. Downing had come to Kearney in the 1870s and owned a saddlebag shop. In 1931, Downing's daughter Maren gave the home to the Kearney Women's Club. The house is now listed in the National Register of Historic Places.

Many of the people who chose to live in Pioneer Park were involved with banking in some way or another. On Central Avenue alone, there were at least five banks in 1892. Seen here is the Andrews Block, which was home to one of those five banks. The third story of this building was later removed.

Another interesting structure in the neighborhood was the First Baptist Church. Designed by local architect George William Frank in the Richardsonian Romanesque style, which he often favored, it is made out of pressed brick. Pres. Harry S. Truman, on his presidential campaign, stopped at the church for a Sunday mass. The church is now a private residence. (Courtesy of the University of Nebraska at Kearney, Frank House.)

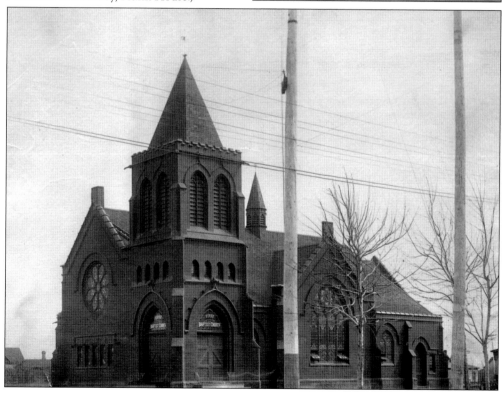

The earliest occupants of this home were the Meserveys, in 1904. Arthur Meservey was a dentist whose office was in the Kearney Opera House. Pauline Frank, the wife of Augustus Frank and one of Kearney's first librarians, is most noted for living here.

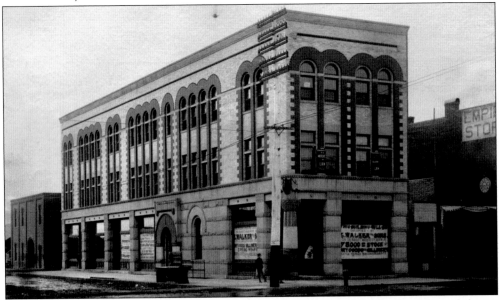

John J. Bartlett, an important banker in the early history of Kearney, built his Eastlake-style house on the western end of the neighborhood. Later, he purchased a lot in the Kenwood neighborhood and built an impressive, eclectic Queen Anne home. Both structures still exist as private residences. Seen here is the present-day Tru Café building, which was a business structure on Central Avenue that Bartlett owned. (Courtesy of the University of Nebraska at Kearney, Frank House.)

A.O. Thomas, the first president of the college, built his home, seen above, barely a block away from the campus. His house was designed in 1905 by George A. Berlinghof in the Neoclassical Revival style and made out of the same stone as the college administration building. Rumor had it that Thomas snuck over to the worksite of the building in the dead of night and stole some of the stone for the construction of his home. Today, the house belongs to the University of Nebraska at Kearney and functions as the Alumni House. The photograph below shows the home next door to the Alumni House, with the house in the background on the far right.

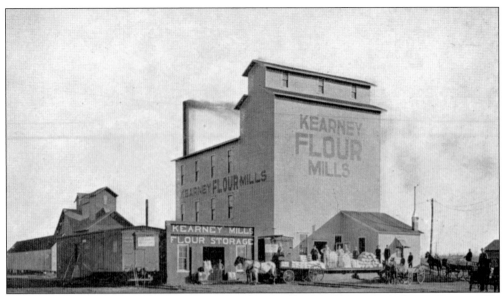

Rollin L. Downing established the Kearney Flour Mills, one of Kearney's first industries. He was also a lumber dealer and the president of the Kearney National Bank. The family home was located on West Twenty-first Street. The home that stands there now was built in the 1920s and is not the original. Several people in the Kearney area also had the last name Downing, but many were in fact not related.

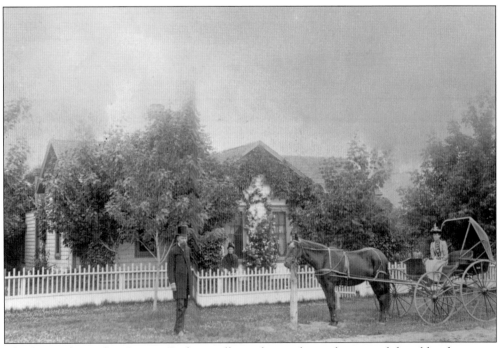

This house, located in Pioneer Park, is still standing today and is one of the oldest homes in Kearney. In the 1930s and 1940s, many residences were covered in a fireproof asbestos siding that hid many original details and architectural features. This house and many others are still covered in this kind of siding today.

Ralph and Cordelia Drake built this interesting turreted home in 1910–1911, although the style suggests that the structure is actually much older. By 1917, it was the home of Peter and Bertha Wink. Peter was the vice president of Kearney Land & Mortgage. (Courtesy of the Pioneer Neighborhood Association.)

C.B. Cannon, who ran a local cigar business, built this home in 1907, yet the house is more connected with J.D. Lowenstein, who was an early settler in 1879. Lowenstein was the man responsible for paving the streets with bricks in 1916. The original administration building of the college is visible in the background.

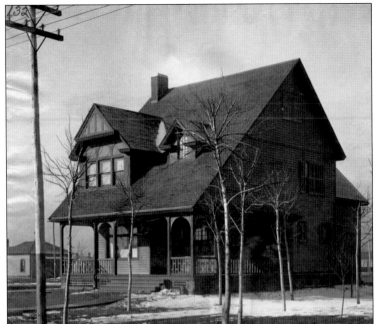

William Spence, the owner of a major dry goods store, built his home in 1889. By 1910, F.J. Everson, a travel agent, owned the house. Designed in the Stick Style, the house has an incredibly steep roof and is featured in the book *100 Views of Kearney*. (Courtesy of the University of Nebraska at Kearney, Frank House.)

Built in 1907 by L.B. Bilion, this house is deemed by an article in the *Kearney Daily Hub* as a "fine modern residence." George Fairchilds also lived here in 1928, and Hary Burke, the longtime superintendent of schools, lived here in the 1930s. The unusual architectural style is marked by the extreme pitch of the roof. (Courtesy of the Pioneer Neighborhood Association.)

Three

KENWOOD

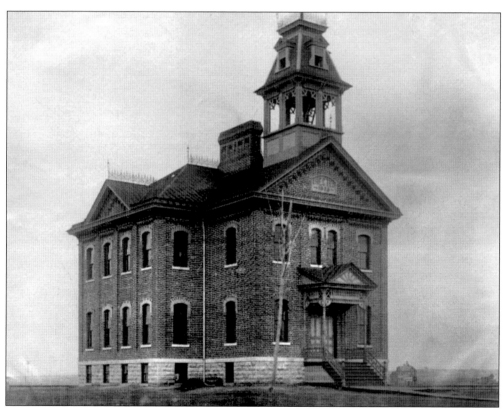

In 1886, a site for a new school building was chosen on the southwestern edge of town. It was first known as the Fourth Ward School, but the name was eventually changed to Kenwood. The school building was torn down in the 1930s and replaced with a new state-of-the-art building. Later, a new Kenwood School was built directly south of the original neighborhood, and the 1930s building became known as Old Kenwood. (Courtesy of the University of Nebraska at Kearney, Frank House.)

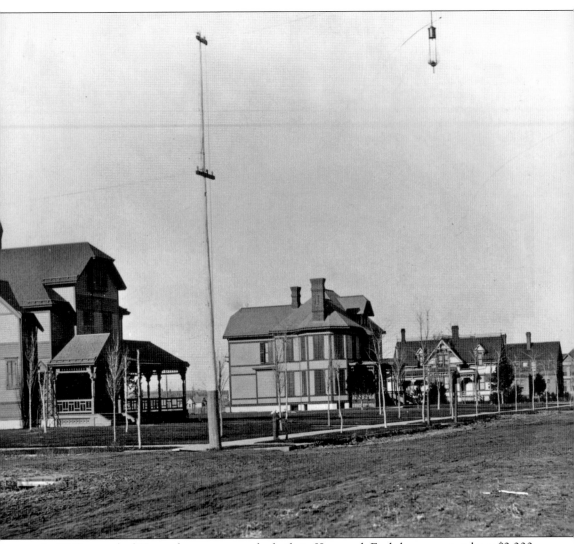

In 1889, a total of 37 new houses were to be built in Kenwood. Each home cost at least $2,000, and the area was advertised as having good streets and walks, lights, gas, telephone service, city water, and access to electric streetcars. Only about 13 of the 37 homes were actually constructed, however, making the Kenwood neighborhood rather small and somewhat exclusive. (Courtesy of the University of Nebraska at Kearney, Frank House.)

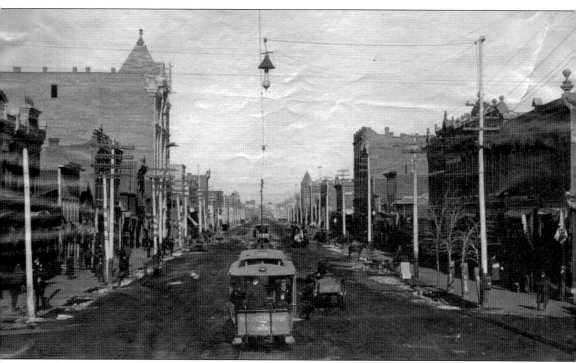

In July 1889, work began on the electric streetcar line to connect Kenwood, West Kearney, and East Lawn with the center of Kearney. This photograph shows Central Avenue in 1892, with the Kearney Electric Company's streetcars. Originally, Central Avenue had horse-drawn streetcars. Also, many of the neighborhood's sidewalks were elevated. The wooden walkways raised up from the mud-clogged streets were often complained about and were said to be very high-maintenance. (Courtesy of the University of Nebraska at Kearney, Frank House.)

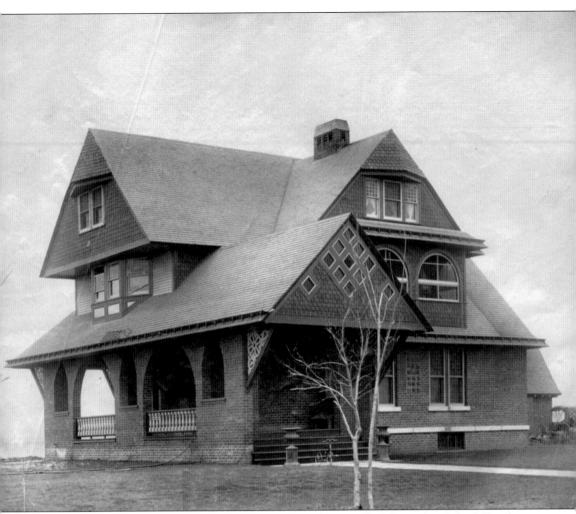

One of the most striking homes in the neighborhood originally belonged to John J. Bartlett, a banker at the Kearney National Bank who also owned a flour mill. He built his home in 1888 in the eclectic Queen Anne style at a cost of around $30,000, which included imported woodwork and other materials. Bartlett did not fare well in the depression of 1893 and eventually had to auction off the house in 1903 for failure to pay taxes. The woodwork and stained glass still survive within the home, and the staircase is completely self-supporting, with no brackets or bolts to bolster its weight. Later, a tunnel was dug connecting the stable to the main house. As the story goes, it is believed that this tunnel was used to sneak alcohol into the house during Prohibition. Today, the home is listed in the National Register of Historic Places.

Another prominent figure who built a home in Kenwood was Bishop Anson R. Graves, the founder of the Kearney Military Academy. Originally located east of the grand East Lawn neighborhood, the academy provided a place for young men to be educated and trained. His house is seen here.

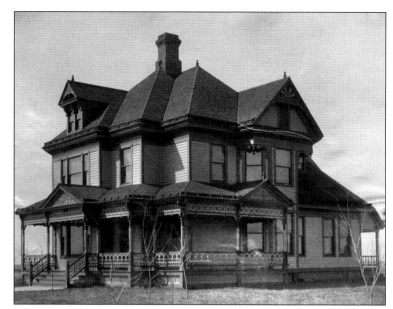

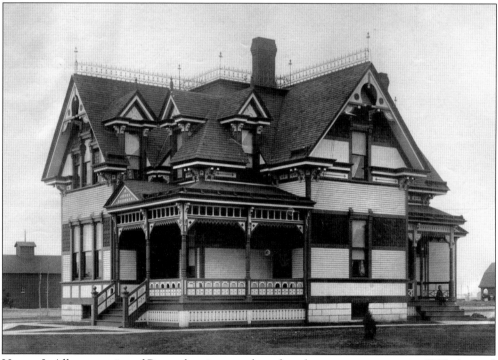

Homer J. Allen, a native of Pennsylvania, was elected as the county treasurer in 1883. Around that time, he had relocated from Shelton to the Kearney area. In 1888, he began involving himself in the lucrative real estate business and helped organize the Kearney National Bank. He also became treasurer of the Kearney Land & Investment Company. In the late 1880s, Allen chose Kenwood as the site for his elegant new home, built in the Eastlake style. The home's second-story windows were "sunken" halfway between the second floor and the main level. Another home was built near the Mount Carmel Home that was very similar in design. (Courtesy of the University of Nebraska at Kearney, Frank House.)

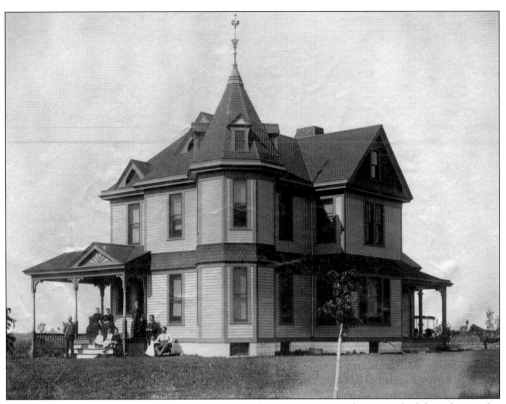

Charles Hanson built this towered home on Ninth Avenue. It was the second of three houses he built. Eventually, when he lost his financial standing for a second time, he sold this house and another he had built in East Lawn to relieve some of his debt. The home still retains its original weather vane at the peak of the tower. (Courtesy of the University of Nebraska at Kearney, Frank House.)

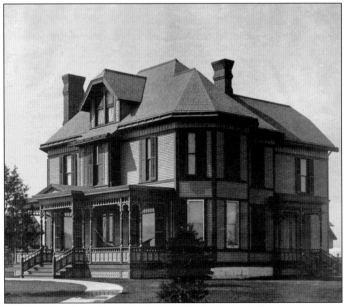

B.H. Bicknell built this impressive home in Kenwood in 1888. Bicknell's mother-in-law lived at the home until she passed away in June 1889. In early 1891, the home was sold to S.B. Humphreys. In December 1890, two months before it was sold, the Bicknells threw a party at the house. It featured impromptu dancing early on Saturday morning and Italian musicians who played harp and guitar. (Courtesy of the University of Nebraska at Kearney, Frank House.)

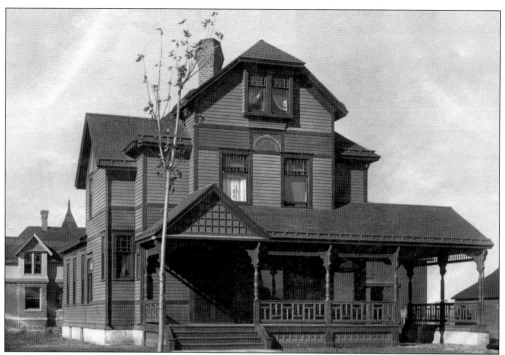

S.B. Humphreys also owned a property next door to the Bicknells. It was designed in a more interesting style and was built in 1888. Note that the house looks as if it was just finished, as the front yard is nothing more than dirt. After several renovations and additions, the home exists today as apartments. (Courtesy of the University of Nebraska at Kearney, Frank House.)

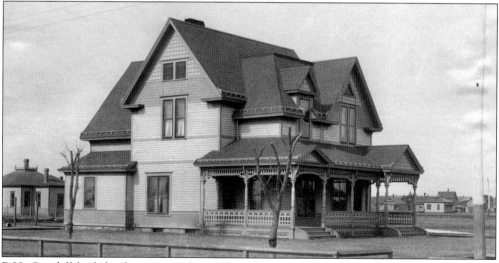

B.H. Goodell built his home near the tracks on the north side of Kenwood. Goodell was the vice president of Farmer's Bank, which had a capital stock of $50,000 in 1890. He also worked for the First National Bank. The Goodells moved into their home in January 1890 and held an extravagant housewarming party on January 21, 1890. The *Kearney Daily Hub* reported that the "handsome residence of the Goodell family was a blaze of light, and a scene of charming gayety." According to the article, nearly all of Kearney's "upper crust" were there, and the party lasted until long after midnight. (Courtesy of the University of Nebraska at Kearney, Frank House.)

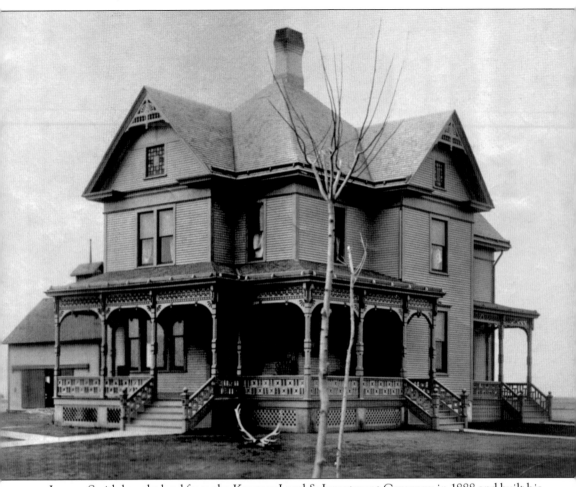

Lyman Smith bought land from the Kearney Land & Investment Company in 1888 and built his Eastlake-style home. C.P. Shun bought the house from him in 1890. It was described as one of the finest residences in Kearney and Kenwood. Rumor has it that a room on the third floor is where the writing process began for the Sixteenth Amendment to the Constitution, which established the income tax. Today, the original porch structure has been changed but the home has been beautifully restored. (Courtesy of the University of Nebraska at Kearney, Frank House.)

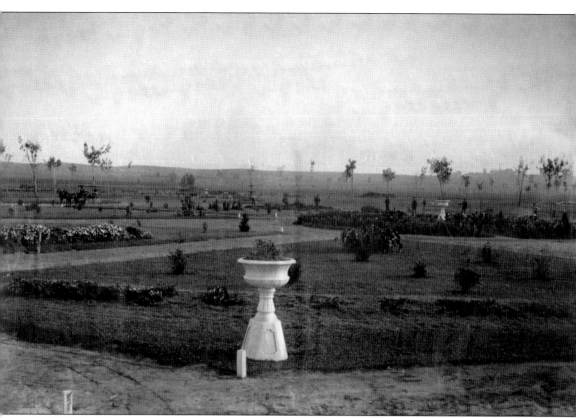

In 1890, the Kearney Land & Investment Company spent, according to a report in the *Kearney Daily Hub*, "considerable time and money in beautifying its Kenwood property" by the work of J.H. Scoutt, who spent much time setting out trees and flowers to fix up the park in the neighborhood. Scoutt went to Omaha to purchase the flowers, and the park was said to rival the one in West Kearney, which is seen here. (Courtesy of the University of Nebraska at Kearney, Frank House.)

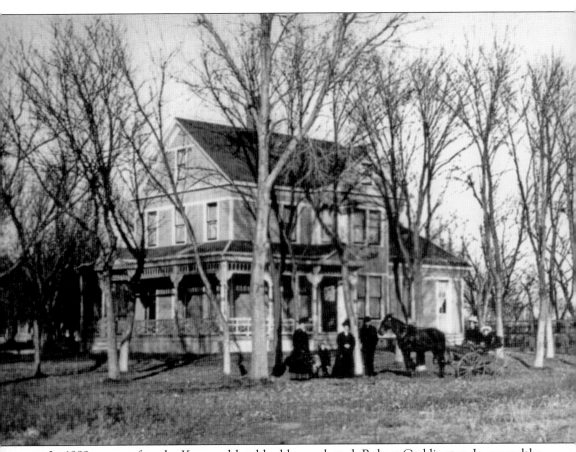

In 1889, a year after the Kenwood land had been platted, Robert Coddington Jr., a wealthy wholesale and retail grocer, chose a spot on the far southwestern edge of Kenwood to build his home. Coddington grew his own vegetables in the backyard. In 1910, the house was sold to C.A. Bartz. Through the years, the home has had hardly any changes, and it is still a private residence today. (Courtesy of the *Kearney Hub*.)

One of the only homes that did not survive in the neighborhood was that of Henry G. Wiley, one of the managers of the Kearney Land & Investment Company, which originally platted the Kenwood neighborhood. In 1897, the company sold out to Lincoln National Bank of Chicago for failure to pay mortgages. In the left background, the original carriage house can be seen. The main house was eventually destroyed by a fire. (Courtesy of the University of Nebraska at Kearney, Frank House.)

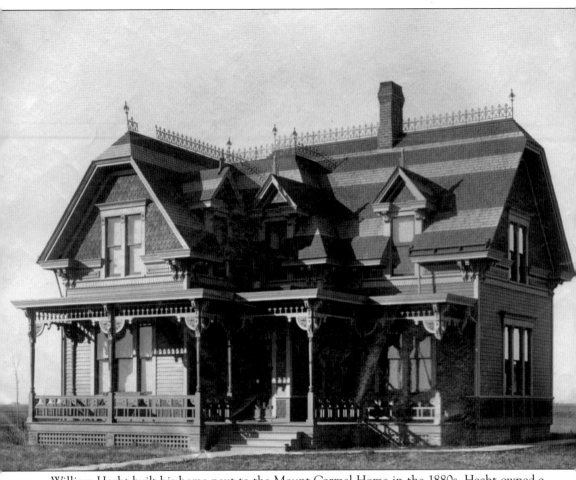

William Hecht built his home next to the Mount Carmel Home in the 1880s. Hecht owned a meatpacking factory. Hecht and his wife spent much time traveling away from the home. One fateful night, the factory burned to the ground and ruined Hecht financially. Eventually, the home was turned into a nunnery named the Catholic Sisters Home. In the 1980s, with the expansion of Mount Carmel, the house was moved to a location west of town on Dove Hill, and it still stands today as a private residence undergoing careful restoration projects. (Courtesy of the University of Nebraska at Kearney, Frank House.)

Four

EAST LAWN

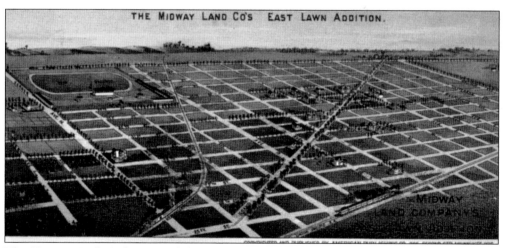

THE MIDWAY LAND CO'S EAST LAWN ADDITION.

The *Kearney Daily Hub* reported that the East Lawn addition was first laid out in the fall of 1888. All streets were graded and planted with trees, as the neighborhood promised to be one of the best-shaded areas of the city. In the center, a large park was laid off with walks and drives complete with encircling trees. An estimated 1,000 trees were planted. The neighborhood was connected to city water, which was available for lawn use and domestic purposes. Seen here is the proposed map for the area in 1889.

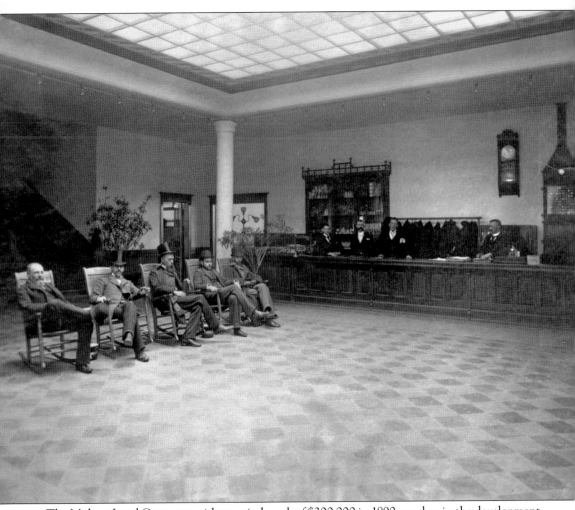

The Midway Land Company, with a capital stock of $300,000 in 1890, was key in the development of much of the city, especially East Lawn. By 1889, the company was advertising the "sale of elegant lots at East Lawn." Many of the company's officers, including Ernest W. Tabor, E.M. Judd, Nelson A. Baker, and Leverrette N. Mowry, chose this neighborhood for the location of their mansions. Most mansions in the neighborhood cost between $35,000 and $40,000. The neighborhood was also very spread out. Seen here is the interior of the Midway Hotel, where the offices for the Midway Land Company were located.

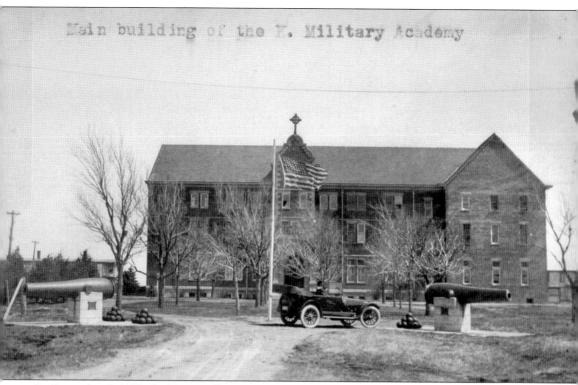

On December 6, 1892, the Platte Valley Institute, better known as the Kearney Military Academy, opened. Board, room, tuition, and heat cost $120 for each student every year. After the depression of 1893, the number of students enrolling became less and less. In the fall of 1898, Rev. E.T. Chittenden took over and changed the school to a military academy for boys, although some girls remained for a short period of time. Enrollment did increase during the Spanish-American War, but, in 1919, the powerhouse burned down and the gymnasium and annex were destroyed by fires as well. Unfortunately, after financial difficulties and low enrollment, the school closed its doors on September 5, 1923. (Courtesy of the *Kearney Hub*.)

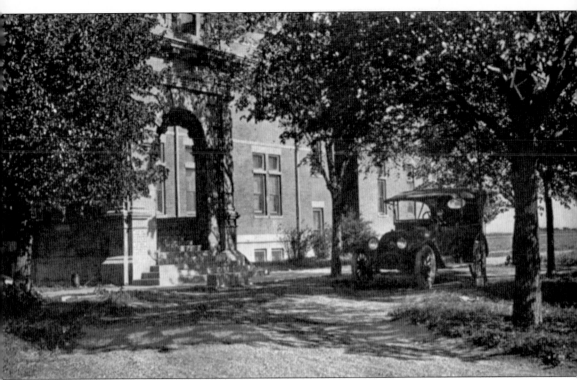

The Platte Valley Institute property sat abandoned for many years. In 1940, the land and the building were handed over to the City of Kearney for public use. The eventually refurbished building housed World War II prisoners and was used for a National Youth Administration (created as part of Franklin D. Roosevelt's New Deal) trades training center. The building also served variously as a hospital, a home for the elderly, and part of St. Lukes Good Samaritan Village. In the summer of 2010, the last structure was torn down. Seen here is the main entrance to Cochran Hall. (Courtesy of the University of Nebraska at Kearney, Frank House.)

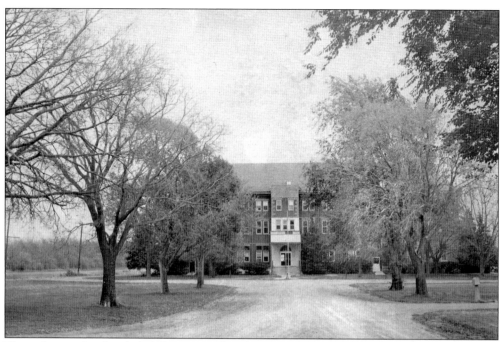

The military school included Kearney Hall and numerous dormitories. In 1905, F.G. Keens went to Bishop Anson R. Graves to speak with him about the future needs of the school. The most pressing issue was that of a new building. Keens offered $10,000 of his own money and said he would raise $15,000 more in Kearney as long as Graves could raise the rest in the East. Eva S. Cochran—the "true mother of the school," stated Bishop Graves—came through with the amount needed. Cochran Hall was dedicated in 1906, with Bishop Graves presiding and William Jennings Bryan as the orator. Cochran Hall eventually became part of the St. Lukes Good Samaritan Village and was the last building to be torn down.

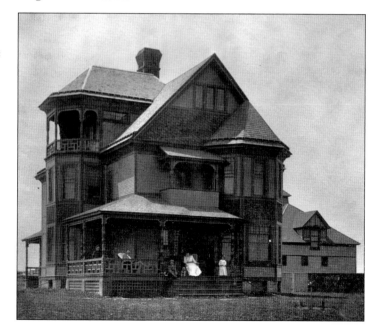

Nelson Baker chose Thirty-fourth Street, the northernmost point of East Lawn, to build his mansion in 1889. Baker had served as mayor of Kearney and vice president of the Midway Land Company. The home housed Baker's family: his wife, Ximena M. Brooks, and his three children—Earle R., M. Claire, and Nell Marie. Baker was also a Knights Templar Mason and a member of the Mystic Shrine. In later years, Ernest W. Tabor owned the home.

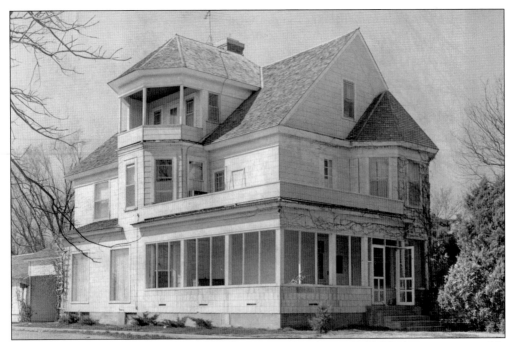

John Bancroft moved into the former Baker house as a young boy in 1946. The home was in terrible disrepair, and the Bancroft family began the long process of restoring it. The interior walls of the house had deteriorated so badly that the outside of the house was visible through them. The Bancrofts built a large guesthouse behind the family home where the original carriage house had been. The guesthouse was made of lumber from the Kearney Airport site. This photograph shows the home roughly when the Bancrofts took possession of it. (Courtesy of the *Kearney Hub*.)

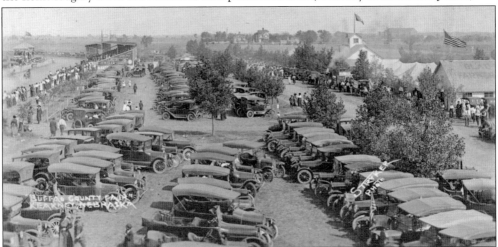

By 1946, all that was left of the original East Lawn neighborhood was gone. To the south of East Thirty-fourth Street, there was nothing but a cornfield. To the west of the Baker mansion stood only one other home. On the south side of Grand Avenue, the land was used for growing flowers that were sold all across the country. The only remaining markers indicating that there had ever been a neighborhood were Baker's house and the Kearney Military Academy. This photograph shows the Buffalo County Fairgrounds. Nelson Baker's home is seen in the center-right distance, and Kearney Military Academy's Cochran Hall is on the far right.

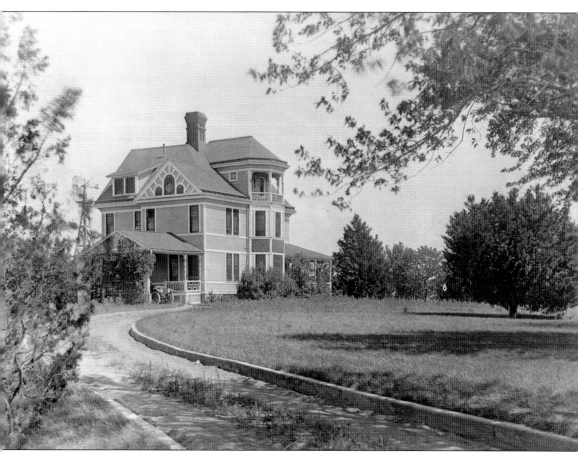

As soon as the new neighborhood of East Lawn was founded, residents were instantly clamoring for an extension of the electric trolley line. On September 9, 1890, the *Kearney Daily Hub* was happy to report that an extension of the electric road would be granted to East Lawn. Engineer John T. O' Brien was in charge of the project, and it is stated that "no grass grew under his feet in the work of preparing the road bed." The electric line ran to the northeast along present-day Grand Avenue, the main artery of East Lawn, before turning onto Avenue Y. From there, it turned west and ran just behind the residences of Nelson Baker and Leverrette N. Mowry, which were described as some of the most elegant mansions in the area. Seen here is another view of Nelson Baker's home, this one from the west. (Courtesy of the *Kearney Hub*.)

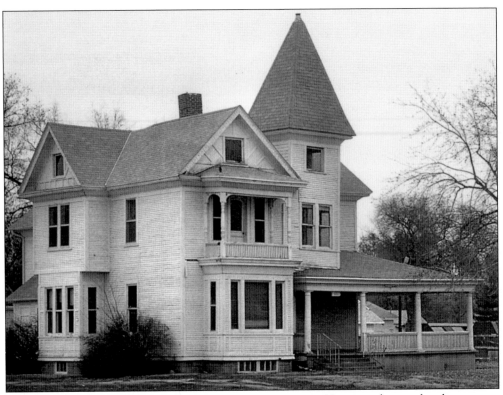

C.A Hempstead also built a glamorous home in East Lawn. Hempstead was a local carpenter and builder who advertised "Lowest Estimates Consistent with Good Work Guaranteed," and advertised often in the *Kearney Daily Hub*. (Courtesy of Maurice May.)

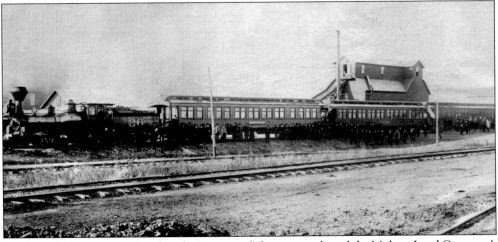

Leverrette N. Mowry, who later bought Hempstead's home, was elected the Midway Land Company's secretary in the company's 1890 elections. His home was located to the east of Nelson Baker's residence. Seen here is a train full of investors, much like Mowry, arriving in Kearney. In May 1906, Mowry decided to move Hempstead's home out of the East Lawn suburb to a new location on the corner of Twenty-fifth Street and Avenue E. It was known as the Steeple House by many before it was turned into apartments and eventually torn down in 2001. (Courtesy of the University of Nebraska at Kearney, Frank House.)

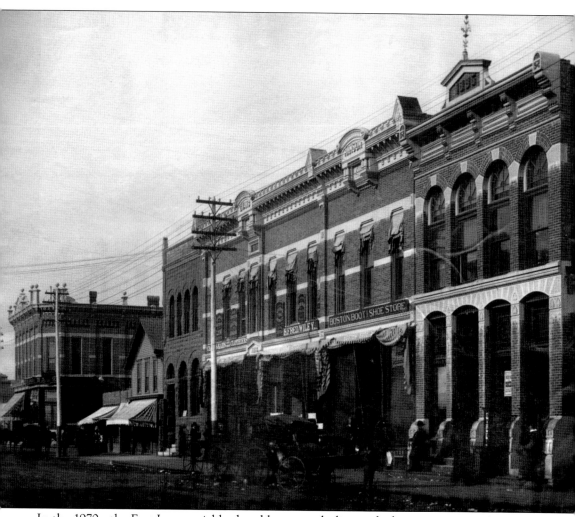

In the 1970s, the East Lawn neighborhood began to decline with the economic trends of the time. Many of the homes in the area were moved to different locations or torn down. One of the houses that was moved out of the area was the third home of Charles Hanson. Born in Sweden on November 19, 1855, he relocated to the United States in 1869. He originally settled in the Chicago area, where he was involved in farming. In the spring of 1879, Charles moved to Phelps Center, Nebraska. He immediately went into the agricultural implement business and sold broomcorn seed as a sideline. In the spring of 1882, Charles, his wife, and his young son Arthur moved to Kearney. Upon settling in Kearney, Charles opened a farm machinery store along Central Avenue, south of the tracks. He also built the brick business building seen here. (Courtesy of the University of Nebraska at Kearney, Frank House.)

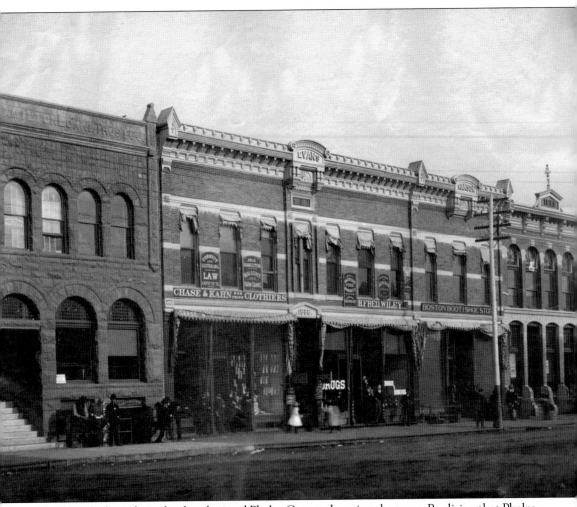

In 1883, the long-desired railroad missed Phelps Center, dooming the town. Realizing that Phelps Center was a lost cause, Charles Hanson cut his connections and became involved in Kearney's development with unchecked enthusiasm. He announced that he was the sole agent for the Garland Patent Steam Roasting and Baking Pan. The next year, he began to work on the first of his homes. In 1886, he started construction on a two-story business building of St. Louis red pressed brick. Unfortunately, Hanson overextended and suddenly found himself burdened with a great amount of debt. Less than two months after his family moved into their new home at 723 West Twenty-second Street, his young son Arthur died on April 24, 1886, at the age of five. (Courtesy of the University of Nebraska at Kearney, Frank House.)

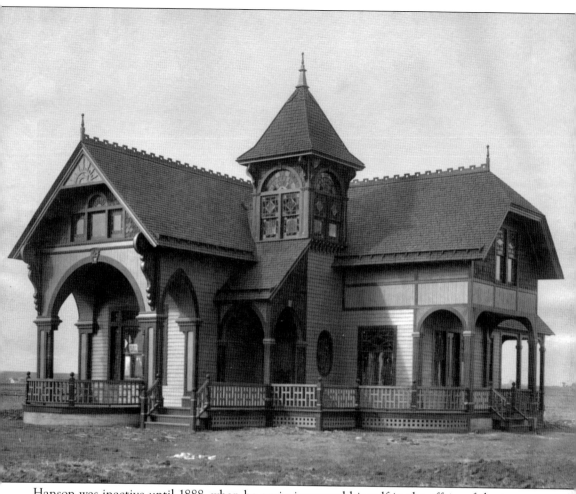

Hanson was inactive until 1888, when he again immersed himself in the affairs of the town by entering into the real estate business. He opened a real estate office in the Midway Hotel and busied himself once more. In the same year, he returned to house-building and purchased lots in the Kenwood Choice Addition and in East Lawn. Hanson's East Lawn home is almost identical to his first home in Pioneer Park. It was not long before Hanson figured out that he had once again overextended himself, this time under a debt of $10,000. He then sold his house in Kenwood, turned his East Lawn home over to the Midway Land Company, and eventually moved back to Chicago. Today, all three of his unusual residences are still standing, with the East Lawn home having been moved onto Avenue B. (Courtesy of the University of Nebraska at Kearney, Frank House.)

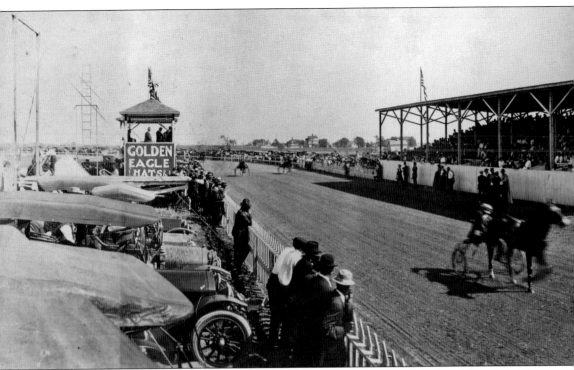

After the economic decline of the neighborhood in the 1970s, the area was turned into a trailer court, keeping the same name, East Lawn. Only Nelson A. Baker's home was lucky enough to stay in its original location, a landmark of the neighborhood's rich history. This photograph shows a portion of a panorama of the Buffalo County Fairgrounds, which are on the outskirts of the East Lawn neighborhood. This photograph shows a race going on, with Nelson Baker's home sitting prominently in the background.

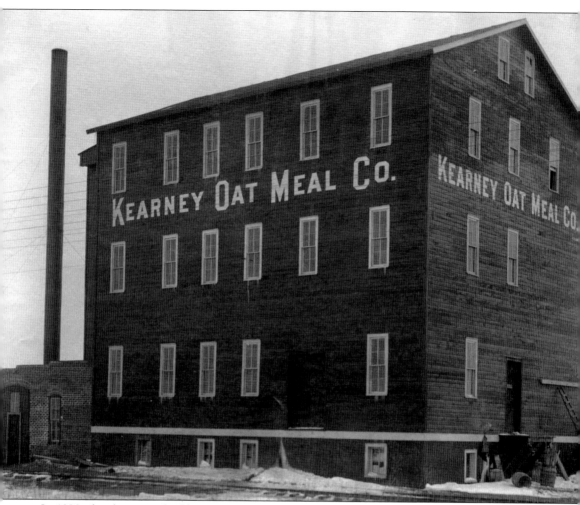

In 1890, this four-story building was constructed for use as an oatmeal factory in the southern portion of East Lawn. The neighborhood was also furnished with 10 fire hydrants, which was the idea of Leverrette N. Mowry, and telephone service was added to a great number of the homes.

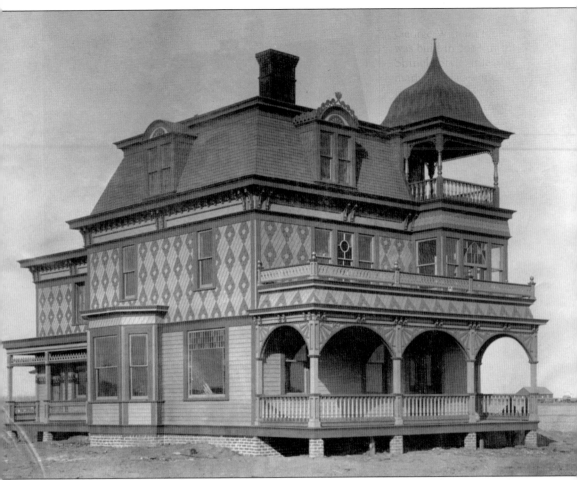

One of the most influential men who chose to build his home in East Lawn was John S. Harrington, a native of Vermont who came to Kearney in 1872. In May 1861, at the age of 19, he entered the Union army, enlisting in Company E of the 3rd Vermont Infantry. He was severely wounded during battle. In 1887, Harrington opened a mercantile business and invested heavily in the real estate business. His home was extravagant, with a huge porch and impressive ornamentation. Harrington and his wife, Sarah A. Eastman, had four children together—Francis L., who was a hardware merchant in Kearney; Clarence Eugene; Wilbur J., who was a clerk in his father's store; and Elmer E. The residence was eventually split in two and taken into Kearney, where each half housed apartments. Unfortunately, the house was eventually torn down.

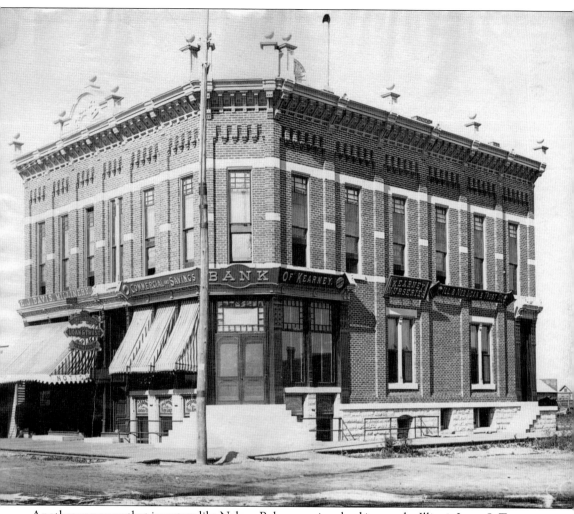

Another company that investors like Nelson Baker were involved in was the Illinois Loan & Trust Company, whose offices were located in the Hamer Block, seen here. Francis Hamer constructed the building in the late 1880s. Today, it is the site of Scorr Marketing. (Courtesy of the University of Nebraska at Kearney, Frank House.)

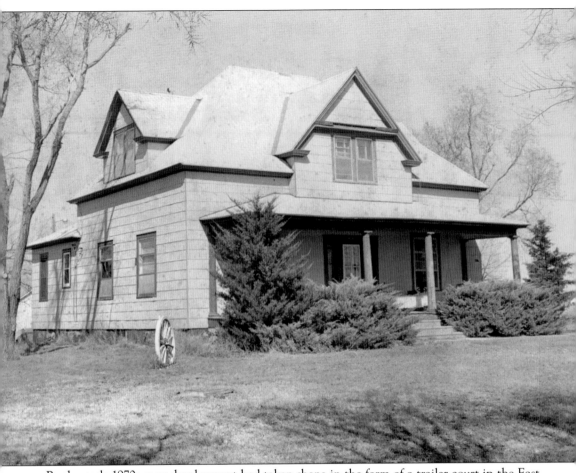

By the early 1970s, new development had taken shape in the form of a trailer court in the East Lawn area. The trailer court was laid out in a circle in half of the original neighborhood. The trailer court took the same name as its once-grand surroundings. Today, the East Lawn neighborhood is associated with its immense trailer park, but it once was connected to something much grander. The home seen here was built later, after the East Lawn neighborhood was established in 1889. (Courtesy of the *Kearney Hub*.)

Five

WEST KEARNEY

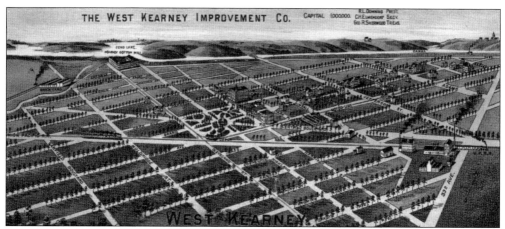

West Kearney was considered to be East Lawn's sister neighborhood. As with East Lawn, the neighborhood became "official" in 1889. The lavish neighborhood was also connected with city water and electric trolleys. The Kearney Paper Company, the West Kearney Woolen Mill, and the West Kearney Brick Works were also located in the area. The *Kearney Daily Hub* advertised the building of a cotton mill there as well.

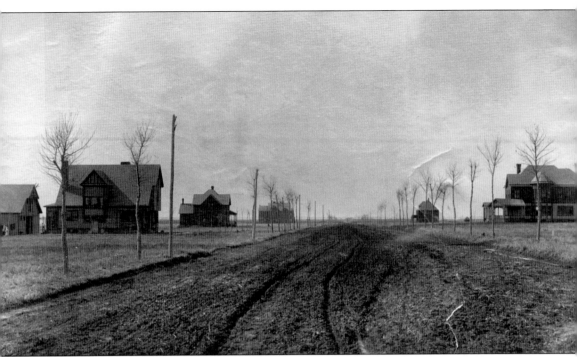

West Kearney was developed in a similar way to East Lawn, by the West Kearney Improvement Company, which also held an officer election in the winter of 1890. Rollin L. Downing was elected president, F.Y. Robertson as vice president, H.D. Watson as secretary, John J. Bartlett as treasurer, and George Sherwood, C.M. Clapp, B.H. Bicknell, O.S. Marden, and Henry G. Wiley as directors. Unlike in East Lawn, however, many of these people did not end up building their homes in the West Kearney area.

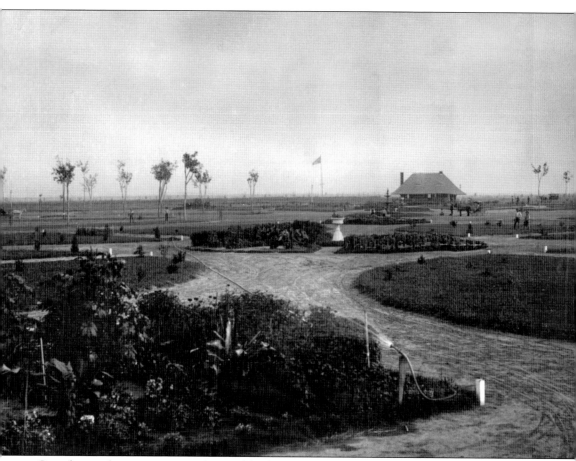

Complete with sewage system, the neighborhood also had a 10-acre park directly in its center, with an estimated 20,000 trees for shade and 5,000 plants. The park also included a fountain and a depot made of pressed brick and brownstone that cost some $7,000. In 1889, the *Kearney Daily Hub* wrote that two lines of electric railway would be installed connecting the neighborhood with the city. Along with the electric lines, the Union Pacific Railroad also ran through the center of the park.

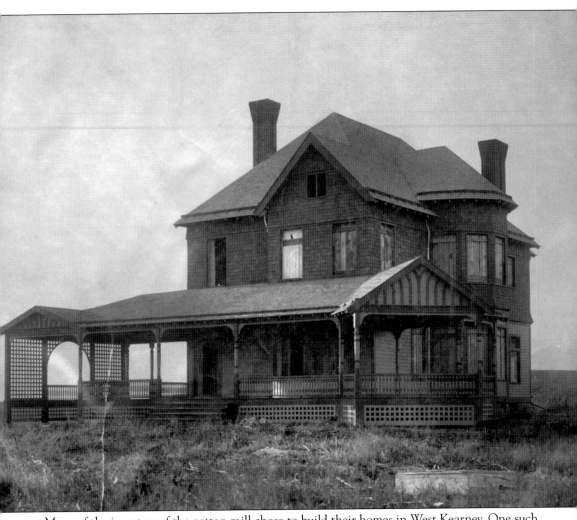

Many of the investors of the cotton mill chose to build their homes in West Kearney. One such man was Walter Cumnock, whose residence is seen here. Cumnock was one of the five brothers who originally started the cotton mill.

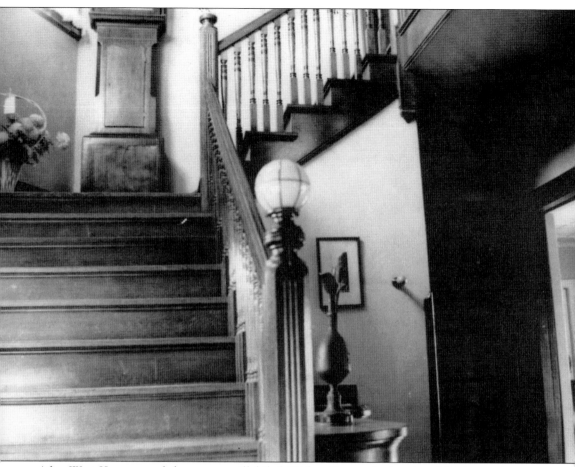

After West Kearney and the cotton mill failed, Walter Cumnock abandoned his house. It was eventually purchased by Will J. Scoutt and moved into the Pioneer Park neighborhood onto Seventh Avenue. Scoutt fixed the home up very nicely for himself, and it was later owned by a fraternity before being torn down in the 1990s. This is an interior photograph of the foyer after Scoutt had remodeled the home.

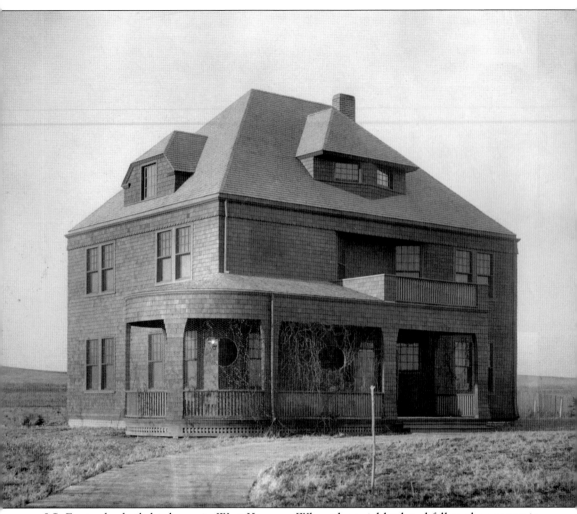

J.S. Foote also built his home in West Kearney. When the neighborhood fell to the economic trends of the 1890s, the house was abandoned. It was later purchased by E.R. Porterfield and relocated into town. It was moved by using large wooden logs as rollers and dragged by a team of horses. A large crowd gathered to watch the house as it crossed the tailrace bridge, as people expected the home to fall through the bridge. The home was later used during World War II to house troops.

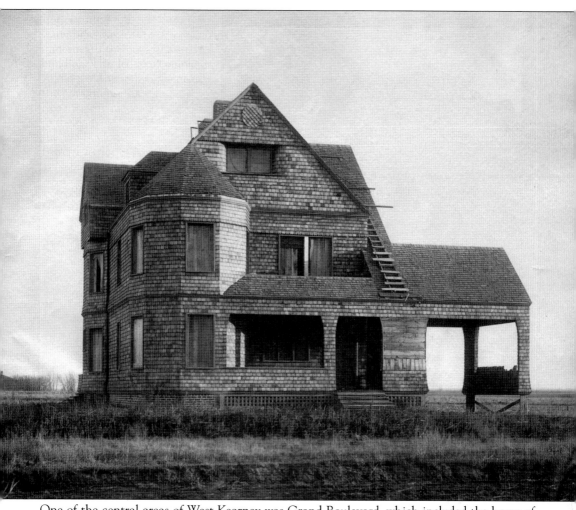

One of the central areas of West Kearney was Grand Boulevard, which included the home of William Smythe. Designed in the Shingle Style, the house is seen here shortly before construction was completed on it. The home was later moved into town but was eventually torn down. (Courtesy of the University of Nebraska at Kearney, Frank House.)

H.D. Watson came to Kearney in 1888 and eagerly launched into the Kearney boom. Watson made the near-famous discovery during a period of drought that alfalfa could still grow in Kearney in such severe conditions, and then proceeded to plant up to 15 acres in 1893. Watson was also the secretary and general manager of the West Kearney Improvement Company. The alfalfa became such a success that 3,000 acres were eventually planted with it. Watson owned and operated a large ranch near West Kearney. The ranch was also known as the 1733 Ranch and was often described as a small city rather than a ranch. Today, Lincoln Highway bisects the area where the ranch was located.

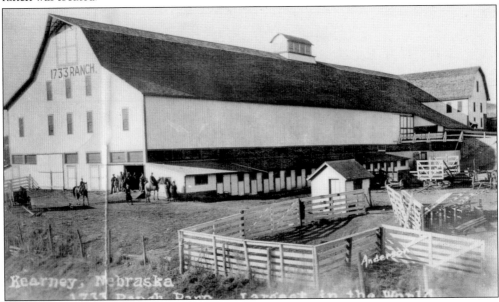

The Watson ranch featured an interesting 40-room ranch house, which was built by earlier owner Capt. David Anderson and located south of the highway. South of the ranch house were 52 small cottages that were provided to those who worked on the ranch. There was also a steam-powered creamery. Shown here is the barn for the ranch, which a Ripley's Believe It or Not! column in the *Lincoln State Journal* publicized as the largest in the world in 1935. Other structures included buildings for housing implements, buildings for the large poultry operations, and many others, including a schoolhouse. There was even a small lake that was fed via the Kearney Canal.

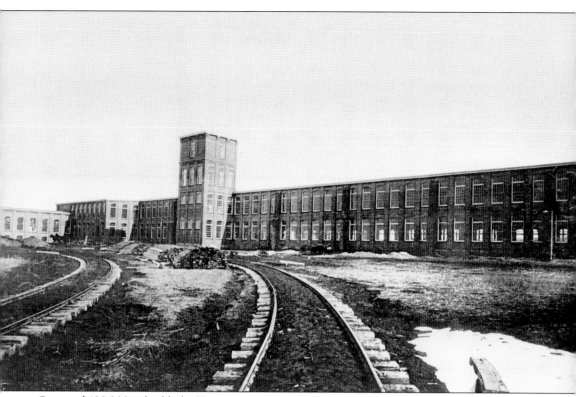

Costing $400,000 to build, the Kearney Cotton Mill opened in 1892 and was the first cotton mill west of the Missouri River and the second-largest industrial building in the state. The cotton was shipped from the South by boat to Plattsmouth, then by rail to Kearney, and the finished product shipped out by rail to the West Coast. George Washington Frank was one member of a group of individuals to suggest Kearney as the site for the mill, and he donated $50,000 in property. The mill was in operation until 1901. Because it operated during the economic depression of the 1890s, it never generated a profit. A cheap source of labor could also never be found to keep the mill running. By 1920, the site had been abandoned and turned into Midway Park, a local amusement park. The mill's basement was converted to a swimming pool, and the main building was used as a dance hall. In 1922, the amusement park grounds burned to the ground. Today, a small section of the cotton mill exists as a private garage off of US Highway 30.

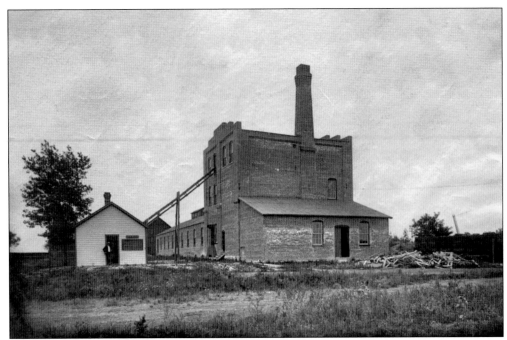

West Kearney was almost a small city in itself rather than a neighborhood. On the projected map of Kearney in 1889, there were plans for a hotel and many other structures in the area. In 1889, the Kearney Paper Mill was built on the eastern side of West Kearney, near present-day Thirtieth Avenue. The mill was built of brick and stone and was equipped with the best machinery available. A large acreage of straw was reserved for the storage of straw for the mill's production of strawboard. Farmers had found a ready market for straw, which they had previously burned. The mill's capacity was reportedly eight tons of paper per day. (Both, courtesy of the University of Nebraska at Kearney, Frank House.)

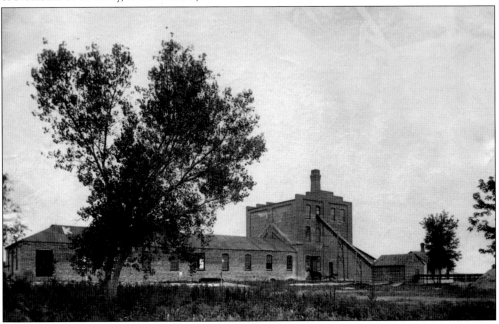

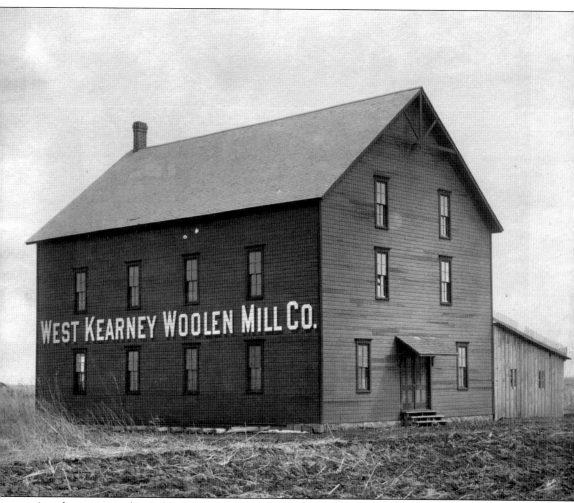

Another major industrial building, the West Kearney Woolen Mill, was right next to the paper mill. Also established in 1889, the woolen mill was a simple two-story, wood-frame building that stood to the west of the paper mill. The Kearney Brick Yard was also located on the far western side of the neighborhood, near the cotton mill.

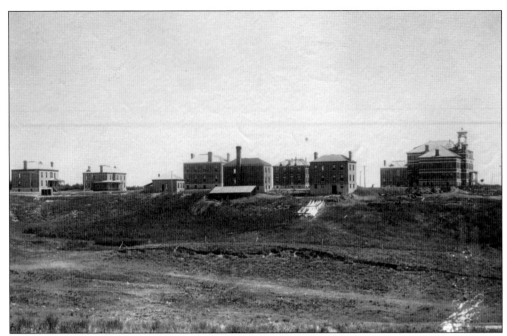

One of the only lasting remnants of the West Kearney neighborhood was the State Industrial School, now called the Youth Rehabilitation and Treatment Center. It was originally founded in 1879 when $10,000 was given from the state legislature for the purpose of creating a reform school. The City of Kearney donated a 300-acre tract of land for just that purpose. The school officially opened in July 1881 as the Nebraska State Reformatory and admitted both boys and girls until a girls' school was built in Geneva in 1892. Many of the buildings were made of pressed brick and were very ornate. Later on, most of them were either covered in stucco or simply painted white.

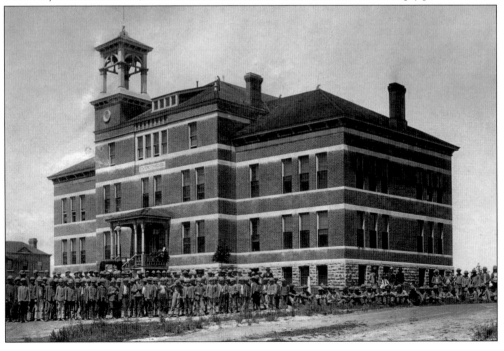

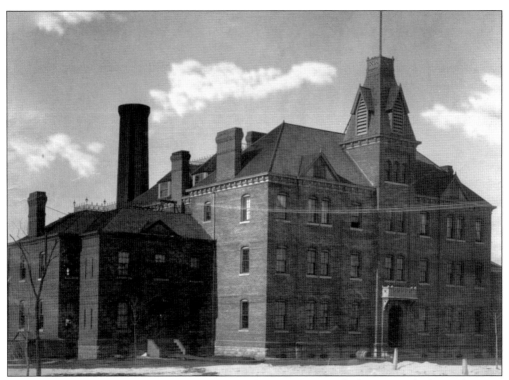

The school did not focus on punishment, but rather on reform and education. The boys who were admitted into the reform school were put into family settings with other boys of the same age and temperament. The main goal of the school was to save Nebraska's young male delinquents before they fell into lives of crime. Rather than being put into a prison-like setting, the boys were placed in family-oriented situations where they learned to respect themselves and others. The boys attended school for half of the day and then worked in fields or shops. Much of the produce farmed at the school was brought to the Nebraska State Tuberculosis Hospital and used to make patients' meals. In 1887, the legislature changed the name to the State Industrial School for Boys.

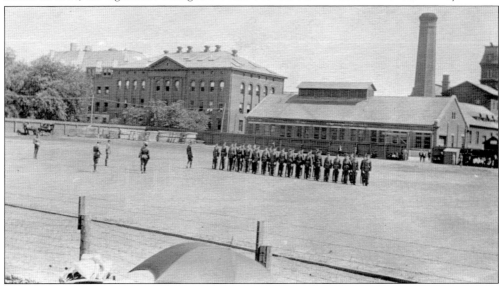

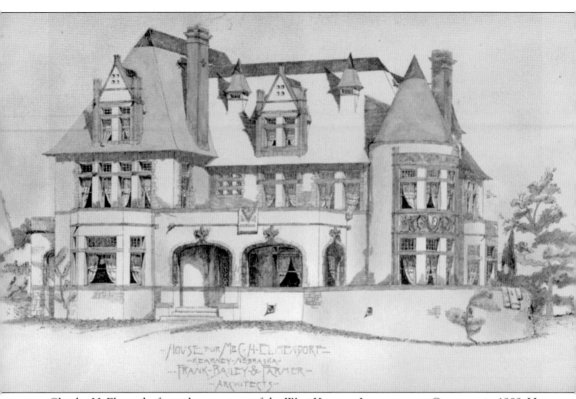

-HOUSE-FOR-MR-C.H-ELMENDORF-
-KEARNEY-NEBRASKA-
-FRANK-BAILEY-&-FARMER-
-ARCHITECTS-

Charles H. Elmendorf was the secretary of the West Kearney Improvement Company in 1889. He was married to Jeanie Frank, George Washington Frank's only daughter. The couple eventually moved to Lincoln. In her father's later years, he lived with them in Lincoln. Later, Charles and Jeanie moved to Los Angeles, where they owned a ranch. The house plan for Jeanie's house is seen here. It was designed by her brother George William Frank's architectural firm. The home was never actually built because of the panic caused by the depression of 1893.

Six

LINCOLN HIGHWAY AREA

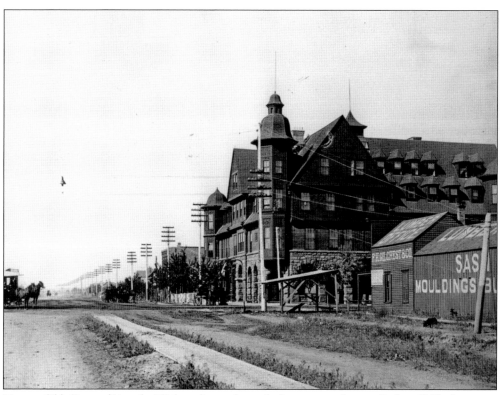

Twenty-fifth Street (Lincoln Highway) ran through the center of town. Before 1905, the street ran straight up to the residence of George Washington Frank. Upon his arrival in Kearney in 1885, Frank completed the town's canal and started an electrical system, introducing Kearney to electricity when it was still in its early years. This photograph shows Twenty-fifth Street and the Midway Hotel around 1889, before the road was incorporated into a national highway. (Courtesy of the University of Nebraska at Kearney, Frank House.)

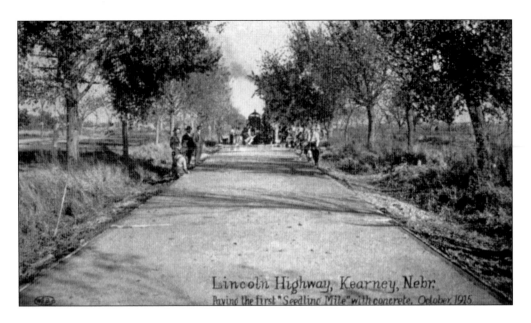

Lincoln Highway, Kearney, Nebr.
Paving the first "Seedling Mile" with concrete. October, 1915

America's first transcontinental highway, the Lincoln Highway was, and still is, one of the most traversed and important roads in Nebraska, never mind the United States. It became one of the first paved roads when certain stretches of the road, called seedling miles, were paved so that motorists could see how much better driving on pavement was than on dirt or gravel. (Below, courtesy of Calvin T. Ryan Library.)

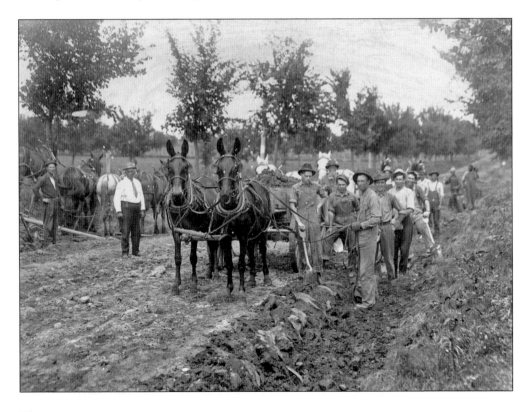

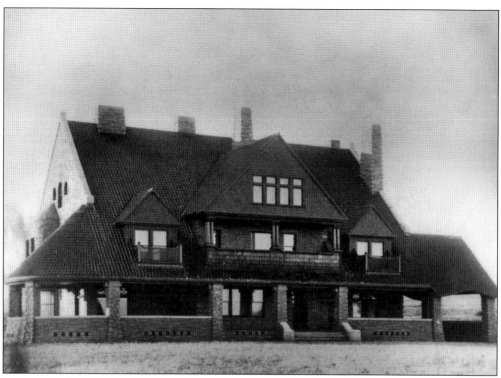

George Washington Frank chose to build his impressive home in a suburb almost exclusively developed by him. The suburb would not pan out in the end because only a small number of homes were actually built. Construction on Frank's home began in 1886 and was completed in 1889. Including furnishings, the house cost $42,000. It was the most expensive, largest home constructed in the area when it was first built. Frank's son George William Frank designed the home for his parents. For the house, George William combined Shingle Style and Romanesque Revival architectures to create a unique blend. These two views, of the front and back of the home, were taken when it was first built. (Both, courtesy of the University of Nebraska at Kearney, Frank House.)

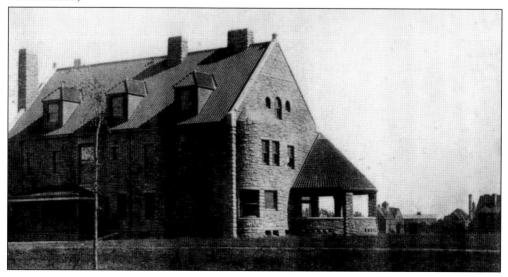

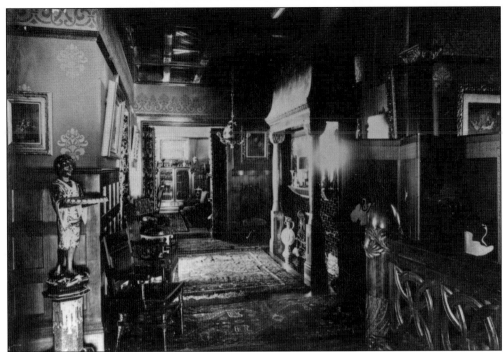

The Frank House is made of Colorado red sandstone mined from Wyoming, a tile roof originally from Germany, and woodwork made of English golden oak and carved by a Swedish woodcarver. The home also features a Louis Comfort Tiffany–designed stained-glass window in the landing of the staircase. Both of these photographs show interior shots of the grand hall. Today, the Frank House is a historic house museum located on the University of Nebraska at Kearney's West Campus and is open to the public. (Both, courtesy of the University of Nebraska at Kearney, Frank House.)

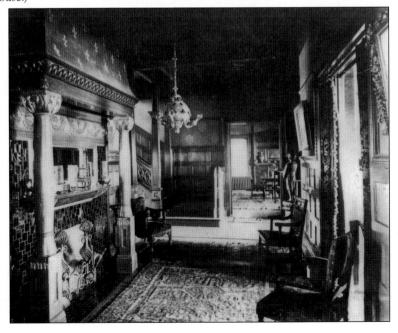

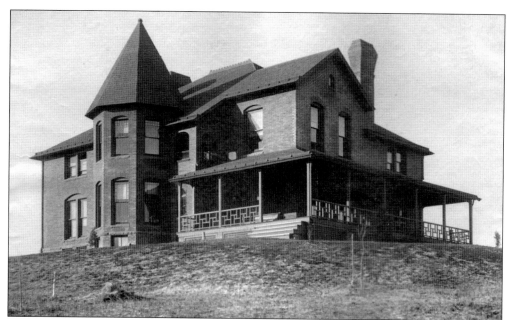

Another home built in George Frank's neighborhood was that of W.C. Tillson. A local banker at Kearney National Bank, which was located in the Kearney Opera House, Tillson built his home on top of what was formerly called Tower Hill. The home was made of pressed brick and, just like the name of the hill, featured a tower on the south elevation. The drive leading up to the home was originally lined with sunflowers, and it was said that Tillson entertained quite a few guests here. The house was eventually sold to the Kearney Country Club, which used it as a clubhouse. Before it was torn down, the house had suffered from many additions and was in bad condition. The current clubhouse of the golf course stands in the exact same location. (Above, courtesy of the University of Nebraska at Kearney, Frank House.)

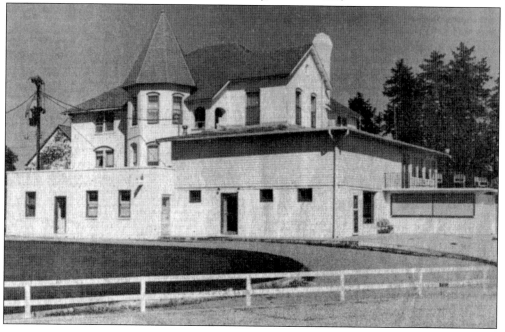

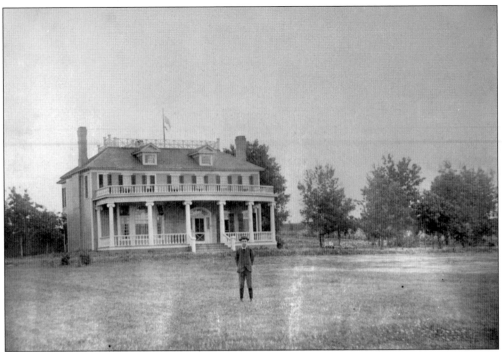

Juan Boyle, who opened a pavilion on Lake Kearney, chose a site just south of Tower Hill to build his impressive mansion. In the 1930s, the house caught fire and was completely destroyed. Today, the property is a parking lot. The interior of the home featured large, ornate fireplaces and intricate woodwork and was fitted with electric lights. (Both, courtesy of the University of Nebraska at Kearney, Frank House.)

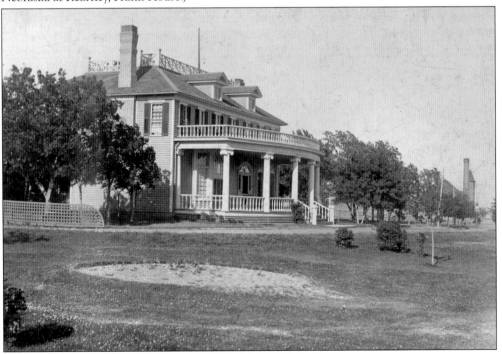

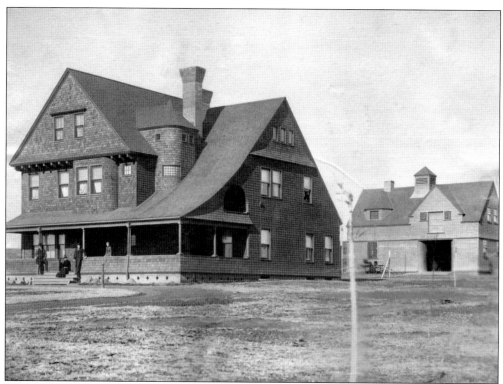

J.C. Currie first lived in this home. It is very likely that George William Frank also designed this Shingle Style house, which later became the nurses' cottage for nurses working at the Nebraska State Tuberculosis Hospital. It was called the Stucco House, although the only stucco was on the front porch. In the 1950s, the house was torn down to make way for a new nurses' cottage. Today, Welch Hall sits in its place. Augustus Frank, George William Frank's brother, also lived in this residence.

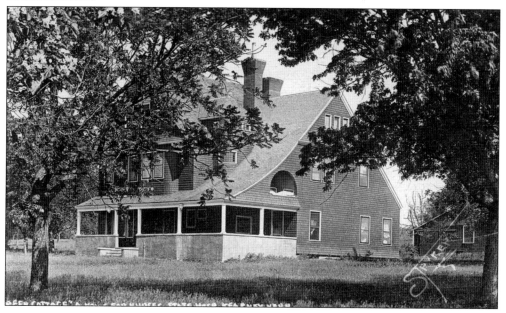

On the north side of the Lincoln Highway, there still exists a posh neighborhood filled with many elegant Victorian residences. One such structure was the first home of George William Frank, seen here. Frank did not live in this house very long before selling it to the Connors, a group of doctors. Frank then chose another site three blocks down the street for his new home. (Courtesy of the University of Nebraska at Kearney, Frank House.)

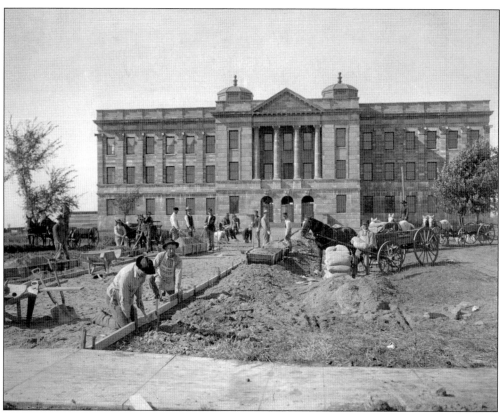

In 1905, it was announced that a state normal school would be built in Kearney. A site was chosen and work began immediately. The site of the college was chosen about a half mile east of George Washington Frank's residence. In 1905, the administration building was erected. It was a three-story building at the head of Twenty-fifth Street, thus cutting off access to Frank's residence. The halls were paved with marble tile, and all of the paneling was white oak. The building was wired for electricity and prepared for gas and water services. (Both, courtesy of Calvin T. Ryan Library.)

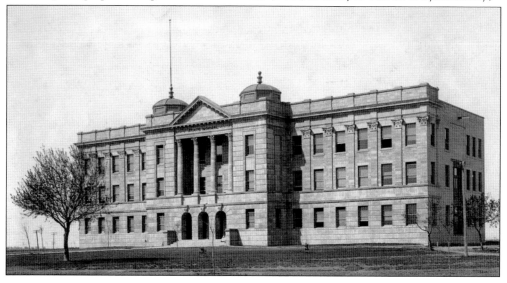

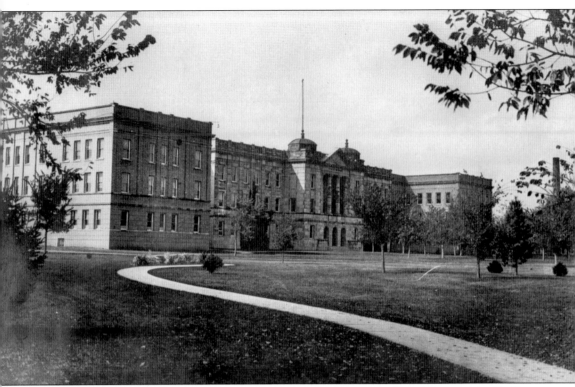

In 1910, the first major addition was made on the north side of the building, known as the Shellberger Addition. The first floor, made of reinforced concrete, housed the library. In 1912, the school added a second addition on the south side of the building that duplicated the north wing, which was known as the Aldrich Addition. The first floor housed model classrooms and the vocational arts. The second floor housed classrooms for German, education, penmanship, and mathematics. The third floor held physical science rooms. (Courtesy of Calvin T. Ryan Library.)

Finally, in 1917, the last addition, an auditorium, was made on the west side of the building. It could seat 1,500 people. The walls were covered in friezes, frescoes, and hand-stenciled designs that represented early Nebraskan agriculture, music, art, and literature. (Courtesy of Calvin T. Ryan Library.)

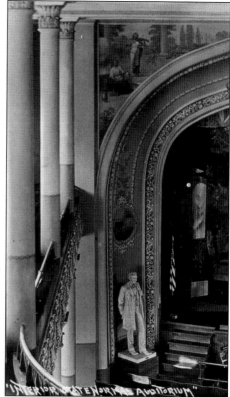

Demolition of the administration building began in the 1960s. It was torn down in the reverse order it was built, starting with the auditorium. In 1984, the original wing of the building was torn down to make way for the modern-day Founders Hall. (Courtesy of Calvin T. Ryan Library.)

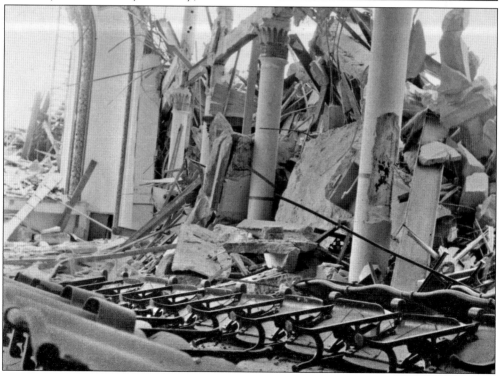

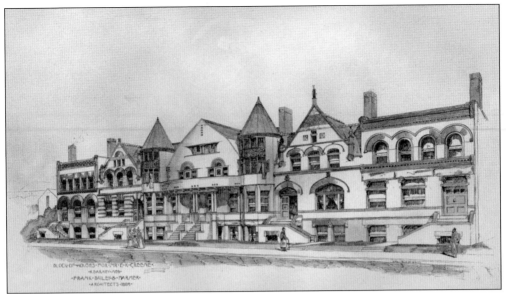

Construction on Green Terrace Hall began in the late 1880s. It was originally built as apartments. The building, made of sandstone, pressed brick, and terra-cotta, faced south on Twenty-fifth Street. The electric trolleys ran in front of the building and ended at George Washington Frank's residence. The building was designed by George William Frank. When the first Midway Hotel burned down, occupants of the hotel were housed at Green Terrace.

In 1905, Green Terrace Hall was donated by the city to the college and became a dormitory for women, who were required to live on campus. It was remodeled into a large reception hall with fireplaces and staircases at both ends. It featured extravagant furnishings and was lit by two bay windows. There were 42 sleeping rooms, complete with porches, iron bedsteads, dressers, washstands, desks, closets, and electric lights. Green Terrace also offered six bath and toilet rooms, but women only received hot water from the heating plant during winter until the first water heater was installed in 1914. The basement had a dining room that could seat 400 people, with fireplaces and large mirrors were also at both ends.

In the building's later years, it became known as Cockroach Castle before it was finally torn down in 1959. Today, the new addition to Antelope Hall sits in its place.

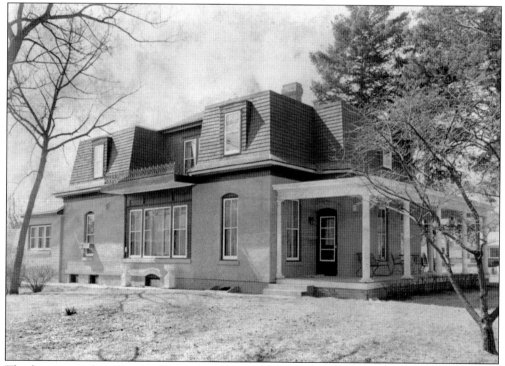

This home was where George Washington Frank first lived when he moved to Kearney. The house originally belonged to Walter Knutzen, a local contractor in town. Knutzen went on to help erect the college administration building, the World Theatre, and many other public structures. Later on, the home was remodeled by adding a second floor. (Courtesy of the *Kearney Hub*.)

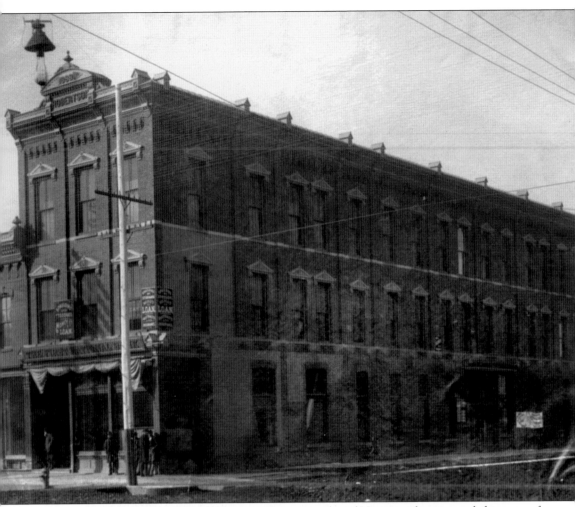

Twenty-sixth Street was filled with many fine examples of Victorian homes, and this area of Kearney still features some of the oldest homes in town. The residence of Stephen A. Douglas Henline was built in the late 1880s on one of the easternmost blocks. Henline was an important Freemason who started one of the first Masonic organizations in Kearney. He owned a large brick business building on Central Avenue (pictured), which was built in 1888. The main floor was a bank, the second floor was home to many offices, and the third floor was used as a Masonic temple. The metal cornice on the top of the building still features Henline's name today. The name Robertson was engraved in the cornice, alluding to F.Y. Robertson, who was president of the First National Bank originally located in the building. When Henline bought the structure, he inserted his name at the top, which is the way it remains today. (Courtesy of the University of Nebraska at Kearney, Frank House.)

The home above, on Twenty-sixth Street, belonged to F.H. Gilcrest, who owned and operated a popular lumber company in town. The Queen Anne Eastlake house has an interesting gambrel roof on the back. It originally had a large wraparound porch, which was later renovated and made smaller, and a balcony was added. Today, the house is used as apartments. Gilcrest's lumber business was based in the building below. (Above, courtesy of the University of Nebraska at Kearney, Frank House.)

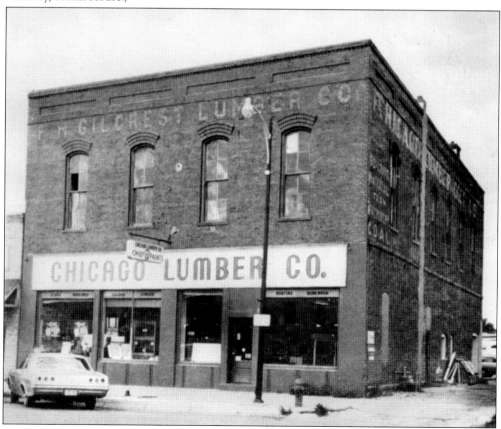

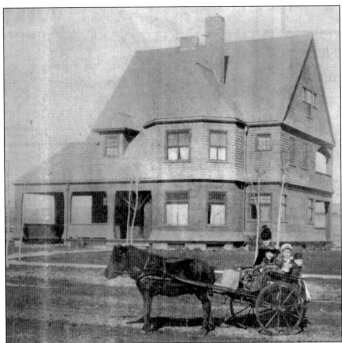

The second home of George William Frank was built in 1884 in the Shingle Style. It featured many fireplaces and intricate woodwork. Frank first came to Kearney with his family in 1884, a year before his father, George Washington Frank, arrived in town. The younger Frank first entered an architecture partnership with Juan Boyle and went on to start the firm of Frank, Bailey & Farmer. The original porte cochere, where people departed from their carriages, was later enclosed and used as a garage. (Courtesy of the University of Nebraska at Kearney, Frank House.)

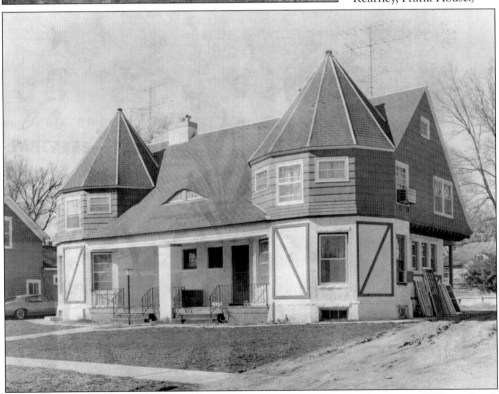

This is another building that was originally constructed as apartments by George William Frank and sat near the college. It later became known as the Normal Apartments and is still used as an apartment house today. (Courtesy of the *Kearney Hub*.)

These two photographs show typical homes built in the early 1900s, shortly after the college was started. The residence above is still standing on Twenty-sixth Street. The two homes below were on Twenty-sixth Street but were torn down to make room for a parking lot.

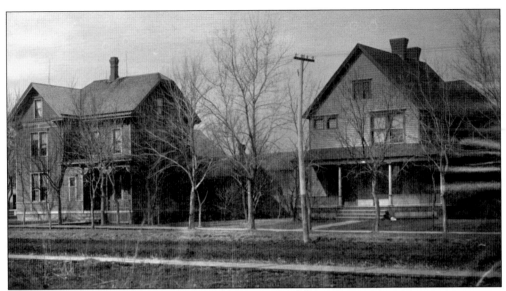

Francis G. Hamer was nominated as a Republican candidate for representative in the Nebraska State Legislature. He was defeated, however, by the joint vote of Democrats and Paddock Republicans. Hamer also helped push for the county seat to be placed in Kearney rather than Gibbon. He then directed his efforts toward building a bridge across the Platte River, helped establish a site for the State Industrial School, and helped fund the building of the Midway Hotel. Hamer was a lawyer and also owned a business block on Central Avenue, which still stands today and has been home to various enterprises. Hamer chose to build his home (above left) in the 1880s next to the home of Stephen A. Douglas Henline (above right). Both houses still stand today and are used as apartment houses. The photograph below shows the Hamer Block when it was still under construction. (Above, courtesy of the University of Nebraska at Kearney, Frank House.)

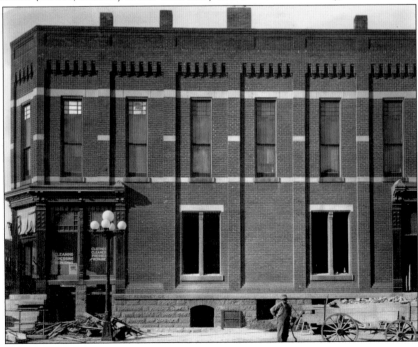

E.C. Calkins relocated to Kearney in June 1873 and worked as an attorney and counselor-at-law. He was born in 1847 in Erie County, New York, and raised on a farm. Calkins was the business partner of Warren Pratt, whose home was in Pioneer Park. Calkins's house was moved to East Twenty-fifth Street in the early 1900s and later torn down. The house was designed in the Shingle Style and featured an interesting two-story bay window.

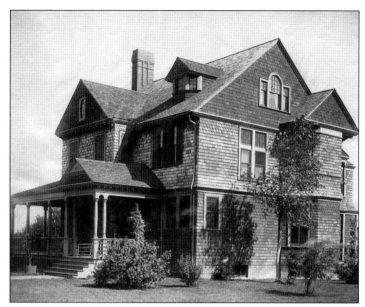

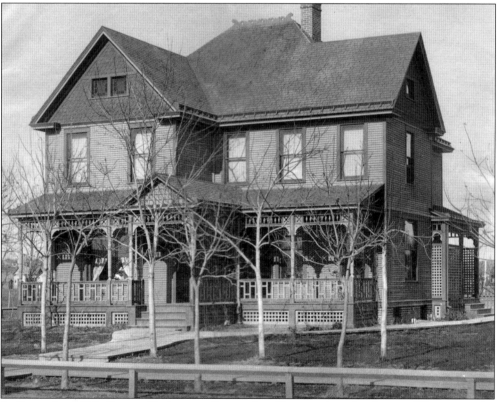

In December 1880, George D. Aspinwall moved to Kearney from his farm in Wisconsin. On January 1, 1881, he was appointed deputy county clerk and served for two years. He then began business as a real estate and loan agent. In 1890, Aspinwall was elected secretary and general manager of the Midway Loan & Trust Company and cashier of the Kearney Savings Bank. His house is seen here.

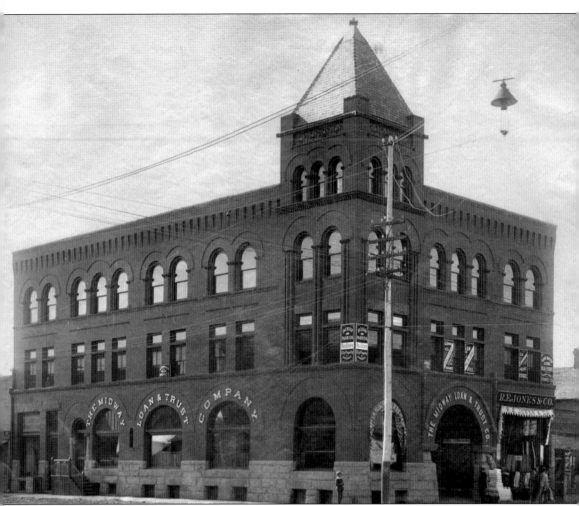

Made of red pressed brick and sandstone, the Midway Loan & Trust Company building was constructed in 1889 and was one of the first structures in all of Kearney to have an electric elevator installed. Its basement and three stories were outfitted for offices, with the best sanitary plumbing and electricity available at the time. A tower at one corner of the building rose 75 feet high, but its pointed roof is no longer part of the structure.

Charles Hanson lived in this large house on the corner of Twenty-fifth Street and Second Avenue in between his bouts of bankruptcy. In the 1960s, the house was turned into a flower shop. By the 1980s, it had been moved off the lot to accommodate the widening of the streets. The house was moved west of town, where it was eventually torn down.

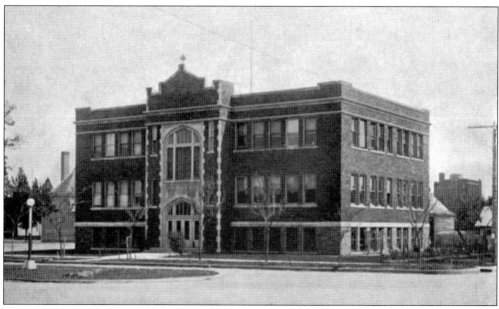

Shown here is the original St. James Parochial School, the forerunner to Kearney Catholic High School, which was built in the 1950s. Today, the structure is known as St. James Square. It is the only original building remaining at the intersection of Second Avenue and Twenty-fifth Street. (Courtesy of the University of Nebraska at Kearney, Frank House.)

One home built in the 1930s still remains on Lincoln Highway. Seen above, it is a perfect example of the 1930s Craftsman style of architecture. The photograph below shows a typical interior of a home built in a similar style.

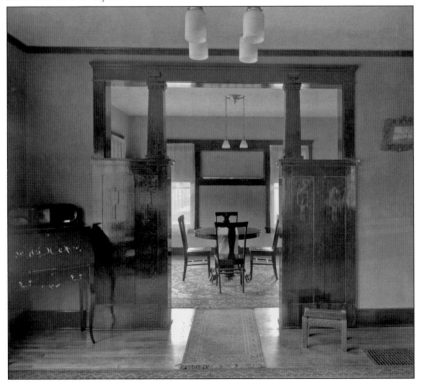

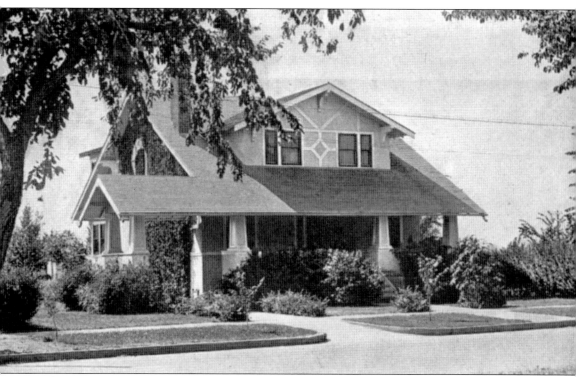

John Stryker was a penmanship professor at the Kearney State Normal School and built his house, seen here, directly across the street from where the library is located today. Stryker spent much of his time taking photographs and made quite a few well-known shots. One of his most famous images shows a view of the Lincoln Highway looking east from atop the administration building. Stryker's home is still standing and is today used for apartments. (Courtesy of the University of Nebraska at Kearney, Frank House.)

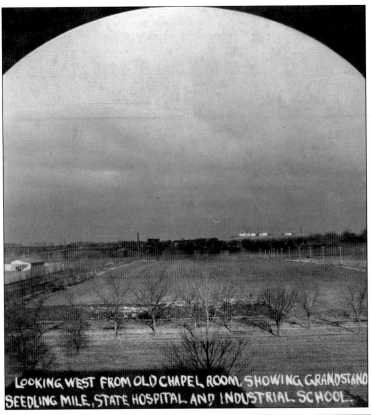

LOOKING WEST FROM OLD CHAPEL ROOM, SHOWING GRANDSTAND SEEDLING MILE, STATE HOSPITAL AND INDUSTRIAL SCHOOL.

This photograph, taken from the back of the administration building, shows the campus of the University of Nebraska at Kearney (UNK) around the time the college was first established. It was nothing more than some fields. Bleachers can be seen to the left, and, in the distance, the roof of the Frank residence is visible, along with the Industrial School. (Courtesy of the University of Nebraska at Kearney, Frank House.)

George Washington Frank commissioned his son George William to construct his new power plant in 1889. Made of pressed brick, the plant was three stories high and replaced the original 1886 building. It was the turnaround point for the electric streetcars, also of Frank's design. When the depression of 1893 hit, Frank lost many of his business investments, which ultimately led to his losing the power plant and electric company. From 1898 to 1919, the canal and the power company were sold four times. (Courtesy of the University of Nebraska at Kearney, Frank House.)

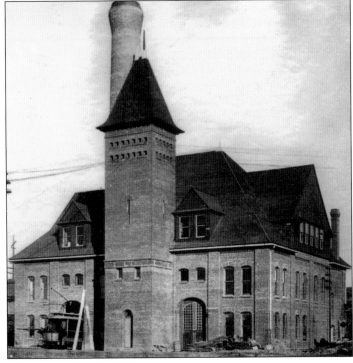

In the early 1900s, a faulty water pipe was installed underneath the powerhouse building. This led to a complete collapse of the spillway beneath the powerhouse, as seen here. Repairs were made immediately to the damaged building. In the 1930s, Consumers Public Power District (now known as Nebraska Public Power District [NPPD]) bought the canal company and erected a new castle-like tower north of the old building. In the 1980s, UNK made an effort to restore the historic power plant, but the building had been abandoned for too long and could not be saved. By 2008, the structure was demolished and replaced with UNK's new power plant, which powers the campus. (Courtesy of the University of Nebraska at Kearney, Frank House.)

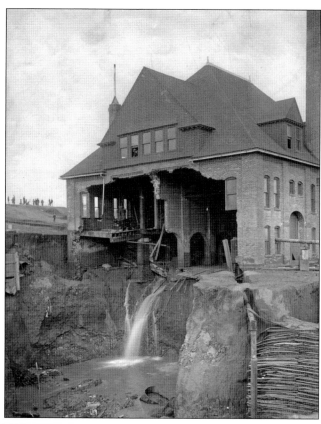

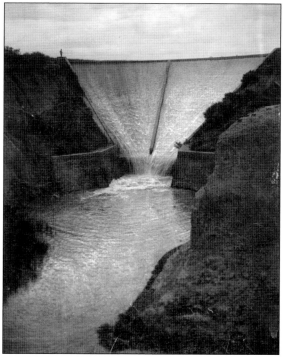

The spillway is seen here after it had been developed. The canal was never originally thought of just for irrigation purposes, as some developers did have the idea of generating electric power, but George Frank was the one who actually came in and helped develop it for that purpose. (Courtesy of the University of Nebraska at Kearney, Frank House.)

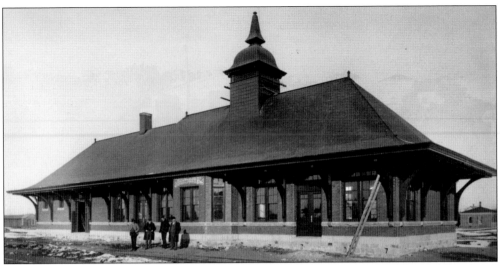

The *Kearney Daily Hub* reported that the Union Pacific depot was constructed of pressed brick and trimmed with Colorado red sandstone. At the time of its February 1981 demolition, the building was the last 1890s landmark used by the community and was believed to be the last building of its design in the nation. (Courtesy of the University of Nebraska at Kearney, Frank House.)

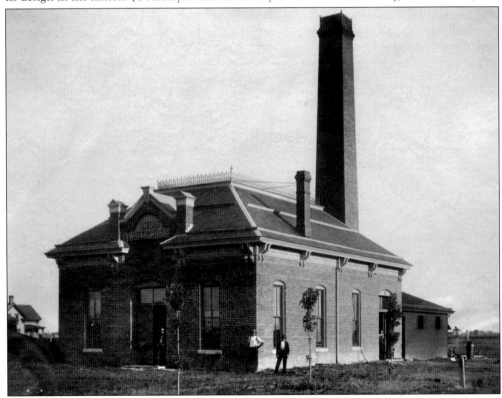

Built in 1886, the Kearney Waterworks building was originally located on the UNK campus, near Green Terrace Hall. The structure served the campus and the surrounding community for many years until it was dismantled in the 1960s. (Courtesy of the University of Nebraska at Kearney, Frank House.)

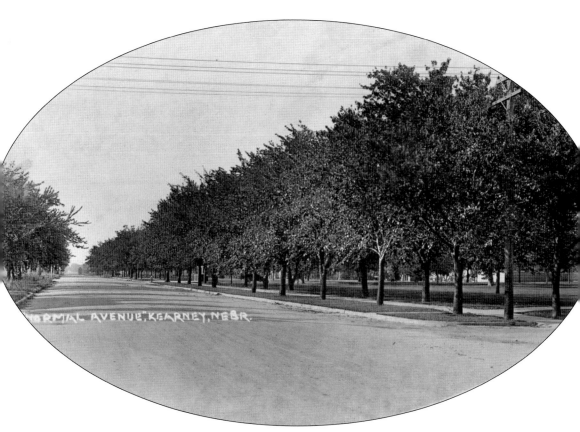

W.L. Keller owned a home on Twenty-fifth Street and operated a butcher shop. By 1910, he had sold his business to F.L. Robinson and Ernest Keller of Michigan. W.L. Keller had apparently been in the butchering trade for a number of years, and the *Kearney Daily Hub* reported at the time that he would invest in the cement business instead. In 1920, Keller constructed a new building on the corner of Avenue A and Twenty-third Street for his new cement enterprise. Shown here is a view looking west on Twenty-fifth Street towards the Kearney State Normal School.

In 1913, construction on the Lincoln Highway began. Kearney was one of the first towns in Nebraska to incorporate a seedling mile, where certain stretches of the highway were paved in concrete to show drivers the benefits of driving on a paved road rather than on a gravel or dirt one. The highway was the idea of Carl Fisher, an Indiana automotive pioneer who hoped that the road would promote economic activity and tourism across America. The highway stretched from one side of the country to the other, connecting New York and San Francisco. These photographs show the road in its early years.

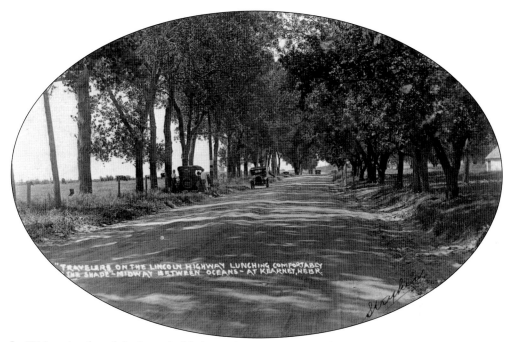

In 1914, a circular of the Lincoln Highway Association was released urging people to plant trees "to Help Beautify the Lincoln Highway on Arbor Day." Many Kearney residents did indeed plant a fine number of trees in an attempt to beautify the road. The highway was surrounded by trees for a number of years before the road was expanded in the 1980s.

The area north of the Lincoln Highway neighborhood was mainly made up of farming fields. Perhaps the farthest settled location north of Kearney was Harmon Park. The oldest section of the park dates back to 1876. It was later named Third Ward Park and remained so for many years. In its early years, the park could only boast of a few drinking fountains and park benches. The name was changed again, to Lincoln Park.

Travelers on the Lincoln Highway would also have seen the giant oxen pulling the covered wagon just outside of town. This building was originally used as a trading post, but was eventually closed down.

This photograph was taken looking west from the fire escape on the back of the Frank House in the 1940s. The museum's parking lot and the canal can all be seen in this view. (Courtesy of the University of Nebraska at Kearney, Frank House.)

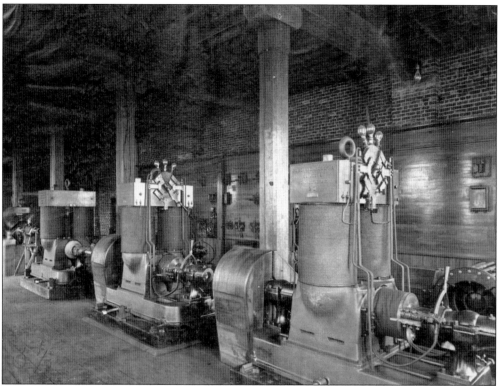

Seen above is the interior of George Frank's power plant, while the home below is a classic example of a model home of the time. Buyers could choose the kind of home they wanted out of a catalog, and the parts and materials needed to build the home would then be shipped by rail to the buyer. Homes like this were very common in the early 1900s, and Kearney has many fine examples.

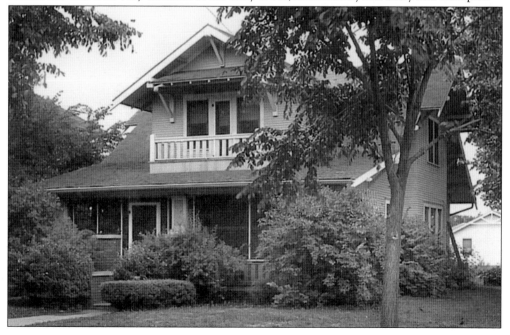

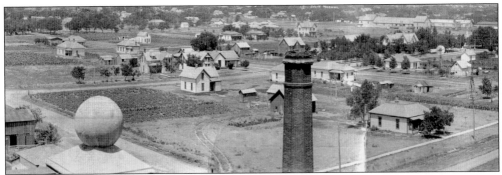

This photograph, taken from atop the dome of the old Buffalo County Courthouse, shows Kearney in the early 1900s. The administration building can be seen in the distance, with other smaller homes in the foreground. Many panoramic and bird's-eye–view photographs were taken from the courthouse dome. The courthouse was torn down in the 1970s.

In 1924, William E. Harmon of New York City organized the Harmon Foundation to provide financial assistance to communities that wished to open playgrounds. Only 50 communities in the nation were accepted for such a grant, and, out of the 784 that applied, Kearney was one of the lucky ones. Seen here is the fountain at Harmon Park, which is still part of the park's flower garden.

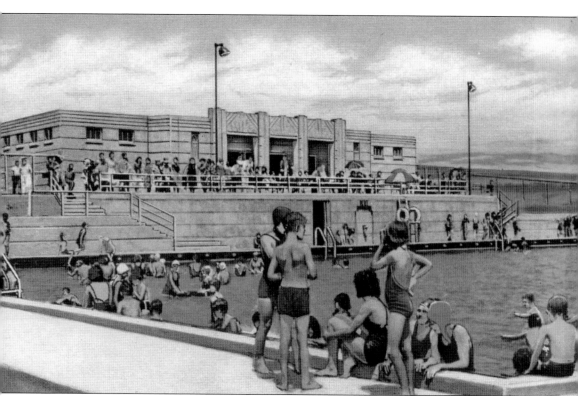

The four-block area granted by the Harmon Foundation was originally given the name Harmon Field. For five years, the park was required to operate under certain stipulations made by the Harmon Foundation. During the Great Depression of the 1930s, the people of Kearney voted for a bond of $35,000 to construct a swimming pool and bathhouse on the west side of Harmon Field. In September, it was announced that a grant of $21,600 had been approved, and construction got underway under the careful watch of Henry Knutzen. The pool opened in late June 1937. In 1986, it was closed for renovations, but it later reopened—and is still being used in 2013.

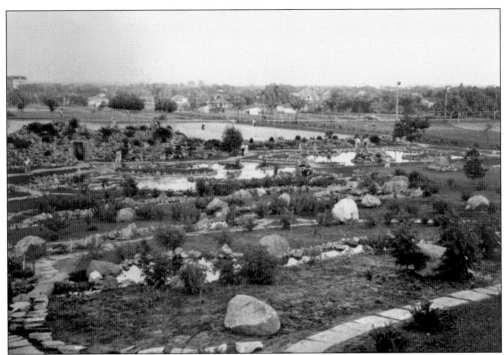

Plans for the rock garden at Harmon Field were initiated in 1936. The park commissioners advertised that the rock garden could be built quickly and efficiently if those who traveled to mountainous areas could bring back one or two oddly shaped rocks for the purpose of starting the garden. The pyramid of rocks across the walk from the lighthouse is the result of this suggestion, and it is said to contain a rock from every state. The rock garden is seen here under construction, with the rock pyramid being built in the background.

The majority of the park was built through a Works Progress Administration (WPA) project that was approved in September 1936. Rocks and boulders were hauled in by Union Pacific flatcars, free of charge, and were all unloaded by WPA workers being paid at least 35¢ an hour.

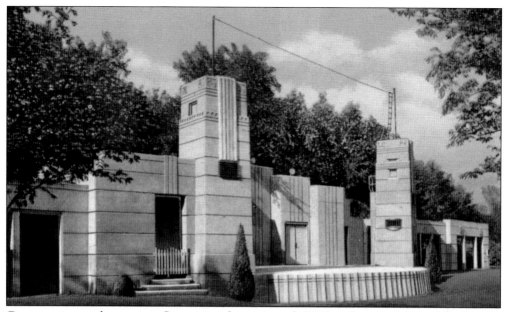

Construction on the open-air Sonotorium began in early 1938, and it was dedicated on June 21. In its early years, the Sonotorium had a very advanced speaker system designed and installed by the Keller Radio Service in Kearney. A pipe organ was also installed that same year, which played "The Star-Spangled Banner" at the Sonotorium's dedication.

A May 6, 1940, article in the *Kearney Daily Hub* describes the construction of the symbolic Harmon Park lighthouse: "Stone is on the ground for the erection of a lighthouse overlooking a portion of the rock garden. It will have a rounding stair. Construction is expected to be under way within 10 days. Incidentally, rocks from the first school, first courthouse and first city hall in Kearney have been used in the rock garden."

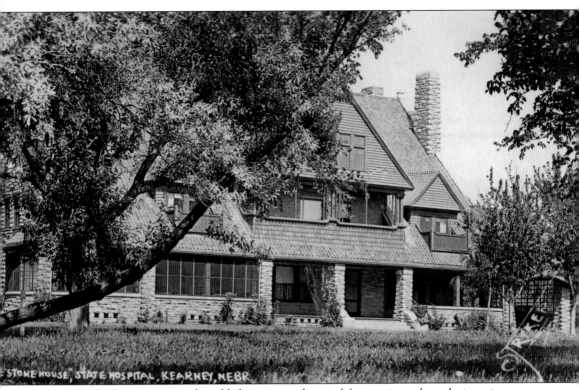

STONE HOUSE", STATE HOSPITAL, KEARNEY, NEBR

In 1911, the first steps toward establishing a state hospital for treating tuberculosis patients were taken with the introduction of a bill by B.K. Bushee. The act was approved and went into effect three months later, and the hospital officially opened in 1912. The site chosen was on the grounds just east of the Frank House, and $40,000 was given to help fund the land purchase and the construction of new hospital buildings. Both George Washington Frank's and Augustus Frank's residences were purchased for resident staff housing. Water from the canal was also used to water lawns in an attempt to keep them fresh and green at all times. (Courtesy of the University of Nebraska at Kearney, Frank House.)

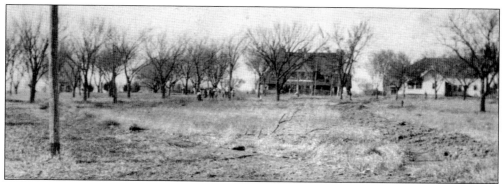

The first hospital building was a two-story brick structure that only had 16 rooms, each capable of holding 32 patients. This photograph shows the grounds of the hospital, with the Frank residence in the center. (Courtesy of the University of Nebraska at Kearney, Frank House.)

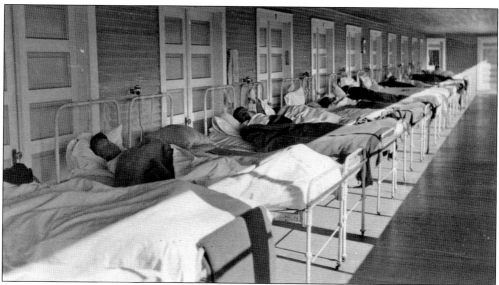

The central portion of the building housed a dining hall, a reception room, and the kitchen, which could easily be converted into additional convenient housing space. This photograph shows patients at the hospital. (Courtesy of the University of Nebraska at Kearney, Frank House.)

By 1922, the original small hospital was beginning to feel the strain of a great number of patients, as it was the only hospital for treating tuberculosis in the entire state. The old building was converted to be used as the cafeteria, and a new building was erected on the eastern side of the hospital grounds. Known as the East Sun Building, it was the first of three construction projects comprising what is now the West Center. The East Sun Building still bears its name above the original hospital entrance.

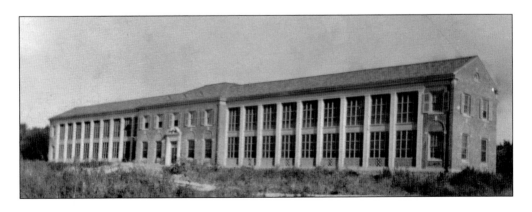

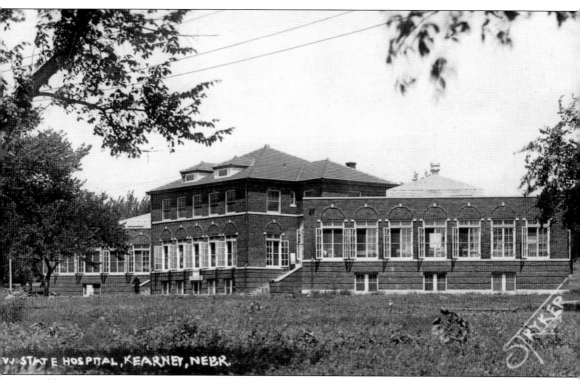

W. STATE HOSPITAL, KEARNEY, NEBR.

Additions were made again on the East Sun Building in the 1930s and 1940s. Now known as the Communications Building, the structure pictured is the original hospital, built in a diamond-shaped pattern to catch as much sunlight as possible. It also housed patients. A pavilion for more staff housing was also erected just north of the Frank residence in the hospital's early years. Within the Frank House, the main floor was reserved for the head doctor or medical director, while the second floor was given to the matron and also used as a recreation area. The third floor, originally servants quarters, was converted into apartments for more nurses.

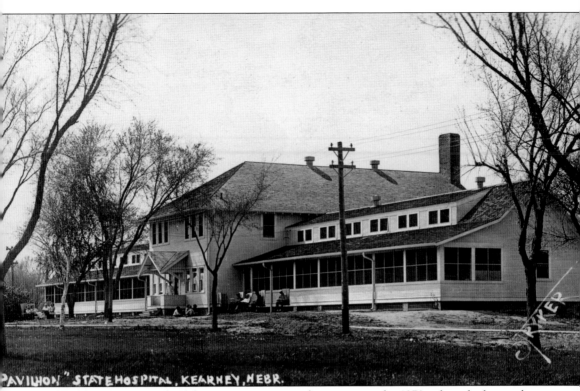

"PAVILION" STATE HOSPITAL, KEARNEY, NEBR.

The pavilion just north of the mansion was torn down prior to the 1970s when the hospital was acquired by the University of Nebraska at Kearney. Seen here is the staff pavilion. The veranda of this building was used to treat patients by exposing them to sunlight and fresh air. (Courtesy of the University of Nebraska at Kearney, Frank House.)

ABOUT THE AUTHORS

Brian Whetstone and Jessie Harris have been active volunteers in their community for quite a while. Both volunteer at the World Theatre and the Frank House regularly. Harris and Whetstone also both lettered in their high school's orchestra and are active members of the Family Career and Community Leaders of America (FCCLA), where they participate in Parliamentary Procedure. Whetstone is also a member of the Kearney High School speech team, Thespian Troupe 1811, and the National Honor Society.

Whetstone and Harris both became interested in their city's history when they started volunteering at the Frank House, a historic house museum in Kearney, and began to discover facts and other information about Kearney. Whetstone also grew up in an older home, which sparked his early interest in both architecture and history. Both students have been awarded with a Volunteer of the Year Award at the Frank House for having put in more than 180 hours of work as of the summer of 2012.

The Trails and Rails Museum is another historic venue in Kearney. The museum has six authentic buildings to tour through, as well as a livery barn, the new JC Marlatt Blacksmith Shop, and a Union Pacific steam engine and caboose. The archive building houses the Buffalo County records and is used by researchers worldwide. The land to the west of the existing museum has been acquired, as the museum will be expanding in the very near future. Readers are welcome to join the museum staff for several special events throughout the year. The museum is located on the original Mormon Trail route (now Eleventh Street). It is owned and operated by the Buffalo County Historical Society, a nonprofit, 501(c)(3) organization. Please visit www.bchs.us for additional details and special events. (Photograph courtesy of Tiffany Valleau.)

DISCOVER THOUSANDS OF LOCAL HISTORY BOOKS FEATURING MILLIONS OF VINTAGE IMAGES

Arcadia Publishing, the leading local history publisher in the United States, is committed to making history accessible and meaningful through publishing books that celebrate and preserve the heritage of America's people and places.

Find more books like this at
www.arcadiapublishing.com

Search for your hometown history, your old stomping grounds, and even your favorite sports team.